MUNCH

AT THE
MUNCH MUSEUM,
OSLO

MUNCH AT THE MUNCH MUSEUM, OSLO

ARNE EGGUM
Chief Curator/Director of the Munch Museum

GERD WOLL
Senior Curator of Prints and Drawings at the Munch Museum

MARIT LANDE
Head of the Education Department at the Munch Museum

Scala Books/Munch Museum

© Scala Books/The Munch Museum, Oslo
© Illustrations: The Munch Museum/
The Munch Ellingsen Group/DACS 1998

First published in 1998 by
Scala Books
143-149 Great Portland Street
London W1N 5FB

Distributed in the USA by
Antique Collectors' Club Limited
Market Street Industrial Park
Wappingers Falls
NY 12590 USA

Editor Sissel Biørnstad
Translator Kate Lambert
Designer WDA, London

Printed and bound in Italy
by Sfera International Srl

ISBN 1 85759 185 2

FRONT COVER
Edvard Munch
Madonna, 1893-94
Oil on canvas

BACK COVER
Edvard Munch
The Sick Child, 1896
Lithographic crayon, tusche and scraping tool on stone

CONTENTS

FOREWORD

IN THE FIRST HALF OF THE 20TH CENTURY the idea of a museum dedicated to an individual artist gained ground. One only has to mention the Gustave Moreau and Auguste Rodin museums in Paris as an example of this type of dedicated museum. Most of these were created on the initiative of the artists themselves. In Norway, Gustav Vigeland benefited from an unreserved act of generosity from the City of Oslo council when it funded the creation of a large studio for the sculptor, which would later serve as a museum for the artist's collection after his death. The city also designated a large outdoor area, Vigelandsparken, for the display of his sculptures.

When Edvard Munch bequeathed all his works of art to the City of Oslo, he therefore had every reason to feel confident that, after his death, his generous bequest would be similarly treated, and that the city would also build a separate museum for his work. Munch's dream of creating a universal art of the constant forces that determine people's lives by placing individual works together in a meaningful whole, also played a part in his great desire for a museum where his pictures could be seen in the right context.

Initially, the vast bequest remained in Munch's studio at his home at Ekely. There, the works were examined and restored. Norway, which had been sealed off from the rest of Europe during the Second World War, re-established many international contacts by sending major exhibitions of Munch's work abroad, first to Stockholm then to Gothenburg and Copenhagen. These travelling exhibitions attracted queues of curious people. Due to a large exhibition which toured the United States of America in 1950, Munch also achieved a breakthrough in the New World.

The role of the Munch Museum over the past few years has carried on this tradition. With changing exhibitions, the museum has constantly presented Edvard Munch's art both nationally and internationally – from Sao Paulo and Los Angeles in the West to

Shanghai and Tokyo in the East. Besides disseminating knowledge on the 'classical' Munch, the museum has organised a series of exhibitions on changing themes which have helped to fill in the gaps in our picture of the artist. Exhibitions such as *Munch and Photography, Munch and his Models*, *Edvard Munch's Portraits* and *Munch and France* were all based on new research. Special exhibitions are shown in the winter season, while in the summer, the main tourist season, the museum exhibits the artist's major works.

The museum's vast collection of works of art, supplemented by a large number of sketches, letters, notes, photographs and other documentary material, is a unique starting point for any research on Munch. The many visitors each year include national and international art historians and researchers, who are given access to the museum's library and archives. The museum's first class, well-organised storage areas are also available for research purposes.

It is my hope that this book will provide an excellent introduction to the museum's collections and present Edvard Munch's life's work as the Munch Museum has presented it to posterity in a form we hope the artist himself would have appreciated.

ARNE EGGUM
Chief Curator/Director of the Munch Museum

THE MUNCH MUSEUM

THE FOUNDATION OF THE MUNCH MUSEUM lies in the artist's testamentary gift to the City of Oslo. When Edvard Munch died on 23 January 1944, in his early 80s, it transpired that he had unconditionally bequeathed all his remaining works to the City of Oslo. It could be said that his last will and testament, signed on 18 April 1940, is the actual foundation stone of the Munch Museum.

The generous bequest consisted of about 1,100 paintings, 3,000 drawings and watercolours, 92 sketchbooks, 18,000 prints and six sculptures, as well as lithographic stones, woodcut blocks, etching plates and a comprehensive collection of notes, books, newspaper clippings, photographs and other documents. Later, Munch's sister, Inger, presented the City of Oslo with a number of works of art, as well as the artist's extensive correspondence.

While Munch had often stated that his works of art formed a collective whole, his will included nothing about the collection having a dedicated building. However, the City knew, and Edvard Munch had seen, that such a task could be achieved. A prime example was Gustav Vigeland's studio and house in Frogner.

The idea of seeing his life's work kept for posterity in its own building must, however, have long been on Edvard Munch's mind. From around 1910, there are in existence a number of sketches by him of a building for the *Frieze of Life* motifs, pictures '…which, together, would give a picture of life…' As time went by, many people came to be interested in the idea of a museum dedicated to his life's work *in its entirety*. One such was Jens Thiis, who, in 1937, proposed a museum for Edvard Munch's art in Tullinløkken, connected to the Norwegian National Gallery. However, this project was not something which Munch wanted. He was afraid there would not be enough room for his monumental works. At the same time, he was strongly concerned with the wholeness and inter-relatedness in his art, and, during the 1930's, he stated on several occasions that the concept of having his own museum was not alien to him: 'My pictures are not commercial pictures, but large sketches and studies which require

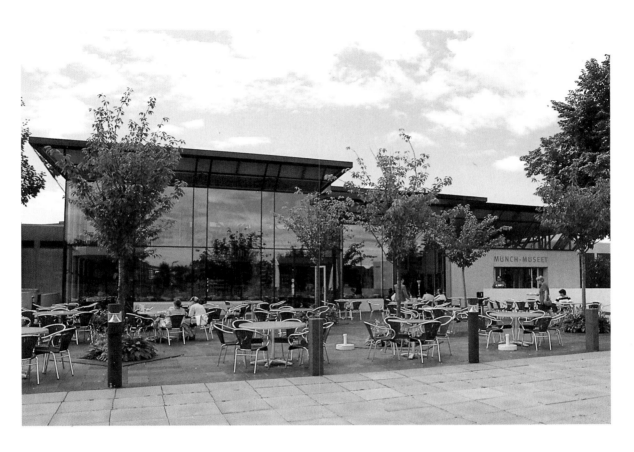

The Munch Museum, which opened in 1963, was built to house Edvard Munch's generous bequest of his works of art to the City of Oslo. A new entrance pavilion and an outdoor restaurant were added in 1994.

a museum,' Munch wrote in a letter to his friend, Christian Gierløff.

Set up in 1945, the committee responsible for the City of Oslo Art Collections also saw the building of a dedicated museum for Edvard Munch's bequest as its most important task. It was thought that this was the only way to ensure that these immensely valuable items would be preserved for posterity and that the people of the City would be able to enjoy them. Oslo City Council decided, as early as 1946, that a Munch Museum should be built, but due to building restrictions after the Second World War, it was some time before the project was able to be put into action.

A number of major problems also had to be overcome before building work could commence, first and foremost the issue of the site. Where should the Munch Museum be built? The art collection's first director, Johan H. Langaard, produced a paper entitled 'The Ideal Munch Museum', which formed the basis for later discussions on the issue. In it, he stipulated that the museum should not just be a gallery, but should also recognise its social function as a cultural institution for the education of the general public.

The paper concluded by proposing the area of Frogner opposite the Vigeland Museum as the site of the Munch Museum. The argument for using this position was that a building here, both in terms of planning and architecturally, could potentially have a major aesthetic impact and be 'an unparalleled asset' to the image of the City. In addition, its proximity to the City Museum, the Vigeland Museum and the Sculpture Park in Frogner would encourage visitors.

In the meantime, the idea of a Munch Museum on the eastern edge of Oslo was fast gaining ground. Rolf Hofmo, then deputy chairman, proposed an area in the district of Grünerløkka, on the east bank of the river, Akerselva. A museum in this neighbourhood would be more in line with Munch's social views than putting his museum in an environment against which he had fought all his life.

When this proposal failed because of the high projected cost of completion, it was proposed that the Munch Museum be built in the south of Tøyen, on land owned by the City. And so it was.

According to his youngest sister, Edvard Munch had never mentioned anything about the location of a prospective Munch Museum. However, she may be able to give us some idea of his views on the matter: 'My view, which I am sure my brother would have shared, is that it ought to be in Tøien. We grew up in and around Tøien. We often visited the museums there. My father had his practice in the Tøien area. My father enjoyed being with the common people, workers and soldiers. My brother inherited that…My brother did not enjoy the western edge of the City. He said to me once that he regretted buying Ekely. We never spoke about the location of his museum, but I am convinced that he would not have wanted it there.'

In November 1953, Norwegian architects were invited by the City of Oslo to participate in a competition to design the Munch Museum in Tøyen, with the project being based, to a large extent, on Langaard's paper, 'The Ideal Munch Museum'. There was great interest in the project and, by the deadline in May 1954, a total of 50 designs had been submitted. First prize went to architects Gunnar Fougner and Einar Myklebust, who were then commissioned. In their design, land and building blocks work in harmony with each other. The jury gave particular praise to the architects' successful grasp of the close connection between the exhibition area and the lecture room, showing how the idea of public education was made real.

After a fact finding mission where the architects studied modern museum layouts, including the Kröller-Müller Museum in Otterlo, designed by Munch's contemporary and friend, Henry van de Velde, a

prototype building was erected on the land. This was used to experiment with light, for demonstrations of materials and the installation of various kinds of partitions. The construction work was finally set in motion in 1960 with Thor Furuholmen A/S as the main contractor.

The Munch Museum in Tøyen was inaugurated on 29 May 1963, one hundred years after the birth of the artist. The cost of construction, approx. NOK 7,700,000, was covered entirely by profits from the City of Oslo's cinemas. The building has a skeleton construction of reinforced concrete and the visible parts of the construction are covered with artificial stone slabs. In all, the museum consists of approx. 1,150 m² of exhibition space on one floor, including the lecture theatre, which is also used for exhibitions. The architects' intention was to create a setting and a space for the works of art which took no interest away from Munch's art. The area intended for the display of a limited selection from the huge collection had an open plan design with movable partition walls, which makes it suitable for changing exhibitions. The room got its natural light from domed skylights, and large panes of glass were installed in the walls with a simple filtering system which allowed the incoming light to be controlled. The office space was kept relatively small, while the lower ground floor contained what was, for the time, a relatively large restoration department. In addition, the building contained a library, photography studios, a restaurant, caretaker accommodation and lodgings for the holder of a scholarship.

It soon became clear that the building was too small. Planners in the 1950s could scarcely have imagined the demands which would be placed on an internationally-oriented institution with major exhibitions abroad, visits from international researchers and, in particular, increased requirements for the proper storage of the works as well as security. At the same time, cutbacks in the budget during the construction period had led to some use of lower quality materials and technical installations. Combined with insufficient maintenance, this necessitated renovation of the old building.

Work on repairing and obtaining funds to extend the building began early on. In the first instance, it was decided to address the issue of the museum's need for more space. The architects of the Munch Museum were contacted and, after a long period of planning, the director's tireless efforts to obtain grants from authorities and funds from private sponsors and with profits from a special art lottery, the new annexe to the south was inaugurated in 1992.

The annexe contains the graphics department, a modern

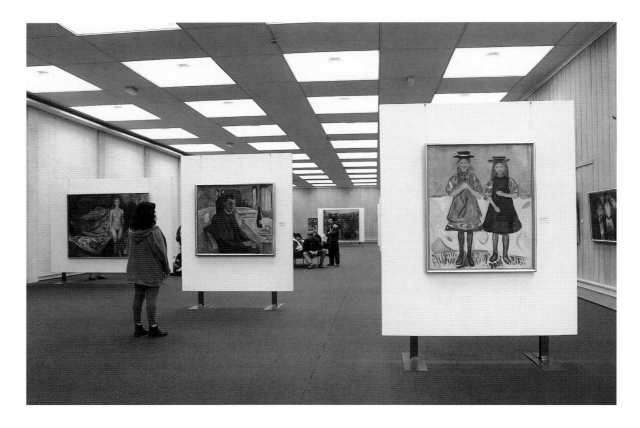

photography department and a new research library. In the library, which consists of 22,000 items such as books, catalogues, periodicals, space has also been dedicated to Edvard Munch's private book collection. Alongside the artist's favourites, such as Ibsen and Dostoyevsky, there are major works of European literature by Shakespeare, Goethe, Dickens and Zola, as well as philosophers such as Kierkegaard and Nietzsche.

On the lower ground floor, there is a new storage area for the collection of paintings. There is also room for a new reception and goods entrance for the Munch Museum's administration, in addition to a central security office. A glass roof has been built to cover the space between the old building and the annexe. Here, a light and airy atrium has been created, filled with tropical plants and other greenery – an oasis of calm for the staff. All in all, the annexe has brought about better and easier working conditions at the Munch Museum.

At the same time as the annexe was being built, a total renovation of the original building commenced and a new pavilion was planned as the main entrance to the Munch Museum. This made more space available to expand the exhibition rooms where the

The Munch Museum's galleries have an open design with movable partition walls which make them suitable for changing exhibitions. During the years, the museum has organised a series of exhibitions on different themes to increase our understanding of Edvard Munch and his art.

actual collection was displayed. At this time, the museum director had succeeded in negotiating a particularly favourable sponsorship agreement with the Japanese company, Idemitsu Kosan Co. Ltd. This ensured that the renovation work could go ahead.

In the former paintings store on the lower ground floor, there is now an education centre, primarily intended for children and young people. Nursery schools can work with drawing and painting in the children's area and a small graphics workshop for children is being planned. The adjoining seminar room is intended for school classes and other groups who wish to work on tasks connected with their visit to the museum. As well as a smaller auditorium with audio-visual equipment, the area also contains kitchen facilities and children's toilets.

At the entrance, there is a pavilion which addresses the practical needs of the public. Here, you can find ticket sales, information, cloakrooms, a well-stocked museum shop and a café. The glass façade reflects the park outside and allows an unhindered view inside. The leafy trees are recreated in the pavilion's columns and panelled ceiling, while the outer building, with its severe lines prepares visitors to enter the world of the great master.

EDVARD MUNCH - HIS LIFE

by Marit Lande

'TWO FORCES LIKE PRIESTS and seafaring folk are no laughing matter!' That is how Edvard Munch himself expressed his view of the opposing forces which he inherited as spiritual ballast. Both literally and metaphorically these two 'forces', represented by the priests and seafarers in his family, characterised his life. It is likely that Munch himself was entirely aware of the core of contrasts and conflicts which became evident even in his early childhood and which finally found release in his art. With a not entirely successful metaphor, Munch sums up how these inherited dispositions governed his life: 'When I cast off on the voyage of my life, I felt like a ship made from old rotten material sent out into a stormy sea by its maker with the words: If you are wrecked it is your own fault and then you will be burnt in the eternal fires of Hell.'

Edvard Munch was born in Løten in Hedmark on 12 December 1863. At the time, his father Christian Munch, a qualified doctor, was medical officer to the military garrison there. When visiting his colleague Dr Munthe at Elverum he became acquainted with the young Laura Cathrine Bjølstad, employed by the family as a maid. The 44-year-old doctor and the tubercular 23-year-old married in 1861.

Munch's parents came from different backgrounds and different environments. Laura Bjølstad's father was a successful sea captain and timber merchant who later lost his fortune. Tuberculosis ran in the family. 'My mother was from farming stock, a strong-willed family, but rotten to the core with tuberculosis,' Edvard Munch told his personal physician. The Munch family, on the other hand, was dominated by the middle class, priests, scientists and artists. 'My father belonged to a family of poets, with signs of genius but also signs of degeneration…' The couple, however, shared a strong and sincere belief in God, which came to characterise their life together and the family home. 'I believe it was the Will of God that we were to have each other,' Christian Munch wrote to his father-in-law.

The year after the wedding saw the birth of their first child,

Christian Munch, 1817-1889. Edvard's father.

Laura Cathrine Munch, née Bjølstad, 1837-1868. Edvard's mother.

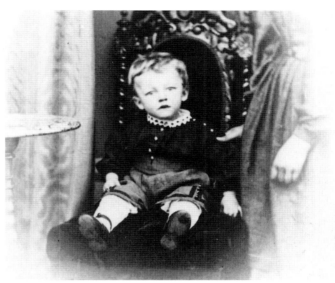

Edvard Munch in his christening outfit, 1863.

Edvard Munch, two years old, 1865.

Johanne Sophie and in the following year the family's first-born son entered the world at Engelhaug farm, which the family rented. The child seemed sickly and the priest was called immediately to baptise him at home. It was not until later in the spring that the baptism was confirmed in Løten church. Edvard Munch was only about a year old when the family moved from Løten.

In 1864 Christian Munch was appointed medical officer at Akershus Fort in Kristiania, as Oslo was called at that time, and the whole family looked forward to living in the capital. They moved into a flat close to the fort and it was there that their three youngest children were born: Peter Andreas in 1865, Laura Cathrine in 1867 and Inger Marie in 1868. Their mother, however, was constantly growing weaker and she herself had hardly expected to survive the last birth. On 12 January 1868 she wrote a farewell letter to her family, addressed to her eldest daughter, in which she expressed the hope that 'we all, who God so carefully has bound together, may meet in Heaven never to part again'. The letter was often read aloud in the family circle and became a guide for Christian Munch in bringing up his children.

That same year the family moved to a new and better flat at Pilestredet 30, in rural surroundings on the edge of the city. Here, Laura Bjølstad died on 29 December 1868. The last memory Edvard had of his mother was from the living room at home. The Christmas tree was lit and 'in the middle of the sofa she sat in her heavy black skirt… calm and pale. Around her sat or stood all five. Father walked

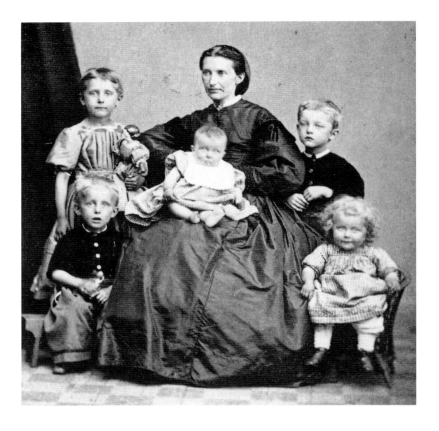

Laura Cathrine Munch with her five children, 1868. Edvard on his mother's left.

up and down the floor and sat next to her on the sofa... She smiled and tears ran down her cheeks...'

Her younger sister, Karen Bjølstad, who had spent long periods with the family helping with the children, then moved in and took over responsibility for the household. Despite the sombre memories associated with that time in Pilestredet, Edvard Munch looked back on these years happily. '...We were healthy there and should never have left that neighbourhood...'

In 1875 the family moved again, this time to Grünerløkka, a new suburb on the eastern edge of the city. Its cold, draughty rented blocks of flats housed industrial workers and craftspeople, some unmarried clerks and a few civil servants. Christian Munch's more well-to-do relatives, however, lived in the more presentable areas to the west of the city. Dr. Munch hoped to boost his modest income from the army as a private doctor in the new part of town. The fact that the family's finances were very poor is probably also due to his poor head for money and his soft-heartedness when faced with patients of limited means.

Karen Bjølstad ran the house with a firm and loving hand and,

thanks to her intelligence and imagination, the family still managed to maintain a middle class standard of living. Servants were taken for granted and the family suffered no real material want. Karen Bjølstad made collages from moss and leaves, a popular genre which she sold to shops in the town. This work made an important contribution to the family finances and was also an important activity for the children in the family. From Aunt Karen, they learned to cut silhouettes out of paper and together created entire landscapes of moss and straw. She was also the one who inspired them to try drawing. The children's work was taken very seriously and the results carefully kept for posterity. Edvard Munch remembered every single drawing and, as an adult, could spend days looking for a special childhood drawing which he knew existed somewhere in the house.

The oldest preserved drawings of Edvard Munch, such as interiors of the family home, show that he worked systematically as early as the age of 12. Most of the drawings from his childhood derive their motifs from items around the house, furniture and other objects. Motifs from adventure and history also appear and here the books his father read aloud were an important source of inspiration. Christian Munch had a keen interest in literature and history. He knew the sagas inside out, and the major work on Norwegian history by his famous brother P.A. Munch was read aloud in the family circle. His repertoire also included adventure and ghost stories.

In 1877 the Munch family suffered a new tragedy. The eldest child, Johanne Sophie, died of tuberculosis. Edvard Munch was himself often sick in his childhood. He suffered from chronic asthmatic bronchitis and had several serious attacks of rheumatic fever. For long periods in the winter, he had to stay indoors and then he received private tuition.

In his childhood the home was, therefore, in every sense the centre of Edvard Munch's life. It was there that he received his early education and there that he arranged to have his first drawing lessons. And it was experiences in the home and the family that came to provide the inspiration for his most important motifs as a modern artist.

In Autumn 1879 Edvard Munch began to study at Kristiania Technical College. It was his father's wish that he should have a technical education, as, in his opinion, that would be the field of the future. Drawing was one of the most important subjects and Edvard Munch made friends with other students who drew and painted in their free time. Frequent absences due to illness, however, led to large gaps in his attendance and in the autumn of 1880 he took the

Edvard Munch, 1879, the year before he decided to become a painter.

decision of his life: 'My decision is now namely to be a painter,' he wrote in his diary on 8 November.

The same autumn he registered as a pupil at the Royal School of Design in Kristiania. His relatives worried on behalf of his father over whether he would be able to make a living, 'Poor Uncle Christian, now there is all that business with Edvard too…' In the spring of 1881 he began to study at the Royal School of Design, in the freehand drawing class, but it was not until the autumn of 1881 that he began to attend with anything like regularity. He then entered the life drawing class where he was taught by the sculptor Julius Middelthun.

Just a year later, however, Munch left the Royal School of Design. Together with a group of young colleagues, he rented a studio in Karl Johan Street, in the centre of the city. A number of painters had studios in the same building, including Christian Krohg, a known and respected naturalist. He offered to give the young painters free advice and such an offer was impossible to refuse. Edvard Munch, however, was not always entirely enthusiastic about 'interference' from an 'old academic' like Krohg. 'Now he has destroyed everything for me', he is said to have said once when Krohg had exercised his pedagogical role with authoritarian discipline. Edvard Munch's debut as a painter took place in the spring of 1883, when he exhibited a painting at the Industry and Art Exhibition, and in December of the same year he took part in the Autumn Exhibition for the first time.

The painter Frits Thaulow was a central figure among the artists of Kristiania. As a prosperous international artist, Thaulow was involved in helping young colleagues of limited means. Frits Thaulow also soon recognised Munch's talent, and approached Munch's father with an offer to meet the cost of sending his son to visit Paris 'to see the Salon'.

At the end of April 1885 Edvard Munch, then 22, was able to travel abroad for the first time. He went first to Antwerp, where he exhibited a work in the Norwegian exhibition at the World's Fair. From there he continued to Paris, and during a three-week stay studied the collections in the Louvre. He also arranged to see the 'Salon', the major annual review of contemporary art in Paris. What else he saw in terms of art or what thoughts he gave to his future work remain unknown. However, the man who headed home after his first stay abroad was a young artist with all his senses alert and intent on new experiences.

In the summer of 1885 Edvard Munch became acquainted with Milly Thaulow, 'Mrs Heiberg' as he calls her in his literary records.

Edvard Munch's entrance card to the World Exhibition in Antwerp, 1885, where he exhibited a portrait of his sister Inger.

Edvard Munch, 1889.

This young woman, who was married to the doctor and army medical officer Carl Thaulow, brother of the painter Frits Thaulow, was to become the first great love of Edvard Munch's life. He began to wander restlessly up and down Karl Johan Street on his walks in the hope of catching a glimpse of her. Now and again they would meet at a studio Edvard Munch rented in the town and the joy and excitement of their secret meetings was soon replaced by a feeling of guilt. 'He had committed adultery… he had cast himself into something which filled him with dread…'. It was the thought of his father in particular which haunted him and the knowledge of his father's view of the sin he had committed. But later, when the memory of his first love had paled in the light of other experiences, Edvard Munch was able to analyse his feelings for Milly Thaulow in a more sober fashion: '…Young and inexperienced – from a monastery-like home – unlike the other Comrades knowing nothing of this Mystery – I met a Salon lady from Kristiania – I stood before the Mystery of Woman – I looked into an undreamt-of World…'

At the Artists' Carnival of 1886, which was also attended by Milly Thaulow and her husband, Edvard Munch came into conversation with Hans Jæger. It is likely that the two, Munch and the notorious leader of what was known as Kristiania Bohemia had met fleetingly before. However, it was probably not until this period during the uproar surrounding the confiscation of Jæger's book *From Kristiania Bohemia*, that Munch became part of his circle. While Munch was to remain as much an observer as a participant in the small circle of artists who called themselves 'bohemians', this meeting marked a turning point in his life. It is likely that it was Jæger's idea of 'writing his life' that inspired Munch's literary works. In what has later been termed 'literary diaries' he began to write about 'spiritual experiences' from his childhood and youth, particularly memories linked to love and death, themes which were later given shape in pictures.

In the spring of 1889 Munch arranged his own exhibition in Kristiania, the first one-man show held in the Norwegian capital. The exhibition covered his entire output and resulted in his being awarded a state travel scholarship to study life drawing in Paris. In the summer the Munch family rented a small house in the town of Åsgårdstrand on the Oslo Fjord, a place which was to become a fixed point in Munch's life. In 1889 he bought a house of his own in Åsgårdstrand, and returned there almost every single summer for over 20 years. This was the place he longed for when he was abroad and whenever he felt depressed and exhausted. 'Walking in Åsgårdstrand is

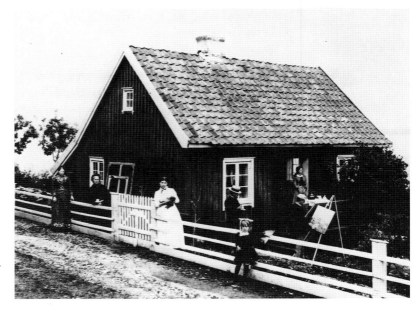

Edvard Munch painting in Åsgårdstrand, surrounded by family and friends. His sister Laura in the doorway and Inger by the gate, 1889.

In Léon Bonnat's studio, Paris 1890. Edvard, who was often absent from the tuition, is present in the caricature!

like walking among my paintings – I have such an urge to paint when I am in Åsgårdstrand,' he said.

In the autumn of 1889 Edvard Munch travelled to Paris on his state scholarship. An express condition of the scholarship was that he would study life drawing and he therefore enrolled as a pupil with the master Léon Bonnat, where a number of other Norwegian artists had also studied. In November his father died and Edvard Munch was unable to return for the funeral. In January he moved to the suburb of

St. Cloud, where he rented a pleasant room with a view over the Seine. For four months Munch went dutifully to Bonnat but after a while he preferred to keep to his room.

After the death of his father Munch fell into a period of depression and, in a mood of deep melancholy, he sought out the Montagnes Russes on the Boulevard des Capucines. It was as if the music and the colours drew him into a world of joy and light and, through clouds of tobacco smoke, he was captivated by a sight which had a surprisingly strong effect on him. The picture of a couple in each other's arms burned itself into his soul and many years later he recalled this experience and put it into words. The impressions from Montagnes Russes here take on the nature of an artistic manifesto as is described in all subsequent literature on Edvard Munch: 'People will understand what is sacred in them and will take off their hats as if in church. I will paint a number of such pictures. No longer shall interiors be painted with people reading and women knitting. There shall be living people who breathe and feel and suffer and love.'

After having seen the Salon, Munch travelled home in May, a little uneasy about his means of support for the future. The summer was spent partly in Åsgårdstrand, partly in Kristiania, and in October 1890 he left his home town again to start his second year of study in Paris. The voyage was via Le Havre, but having fallen ill on board, he had to be admitted to hospital there before he was able to continue the journey. After a few days of 'Siberian cold' in Paris, he travelled south to warmer climes on the Mediterranean. The remainder of the winter was spent in Nice. His money problems led Munch to try his luck on the gaming tables of Monte Carlo, and for a while he was obsessed by the excitement of roulette. But in May he travelled back to Paris to 'see the Salon', and in the summer he returned to his beloved Åsgårdstrand once more.

Due to the long periods of illness during his period of study, Munch's scholarship was extended for a third year. And so for the third year in a row he set sail for France, where, together with the Norwegian painter Skredsvig, he once more spent the winter in Nice. At this time Munch experimented with different methods of painting. For a brief period he worked in purely impressionistic techniques. Later he developed an art reminiscent of Symbolism and Synthetism, within which the subjects were based on the 'spiritual experiences' of his youth and childhood. This was to be developed into the picture cycle known as *The Frieze of Life*.

When Munch was granted the state scholarship for the third

consecutive year, there was some grumbling that he had spent the money on a 'holiday' in the south of France. He then decided to show the results of his time studying in France and in September 1892 he once more opened a one-man show in Kristiania. The exhibition was visited by the Norwegian painter Adelsteen Normann, who was living in Berlin and a member of the Artists' Union there. He was immediately captivated by the paintings and aimed to obtain for Munch an invitation to exhibit his work at the Artists' Union premises in the German capital.

The exhibition in Berlin opened on 8 November, and was immediately declared an 'insult to art'. However, the reaction was against the method of painting, not the subjects and after discussion and a vote taken in the Artists' Union the exhibition was closed after a week. The newspapers were full of 'The Munch Affair', but Edvard Munch himself was in sheer delight over the uproar:...'I have never had such an enjoyable time – incredible that something as innocent as painting can cause such a stir,' he wrote to his family at home. He immediately saw the advertising potential of 'The Munch Affair' and signed a contract with the art dealer Edouard Schulte to show the exhibition in Cologne and Düsseldorf. In December he hired premises at the Equitable Palast in Berlin out of his own pocket, where the public were charged admission. The financial gain, however, was not as high as he had hoped.

Munch had now become a famous figure in the artistic circles of Berlin. In the bar 'Zum schwarzen Ferkel' (The Black Pig) he entered a stimulating environment in many ways reminiscent of the bohemian

Munch - to the right - with a friend in his studio in Berlin, 1894.

Edvard Munch, 1892.

circles at home in Kristiania. He became friends with and socialised with poets, men of letters and philosophers such as August Strindberg, Richard Dehmel, Holger Drachman and Julius Meier-Graefe. The Polish poet Stanislaw Przybyszewski, himself preoccupied by sexuality and free love was the driving force in this environment, which acted as a melting-pot for ideas and motifs. Edvard Munch rented a studio and continued to work on the motifs for *The Frieze of Life*. The nucleus of this picture cycle, where the subjects are linked to love, angst and death, was a group of pictures exhibited in 1893 under the title *Love*. In Berlin he also created his first etchings and lithographs.

For four winters in a row Munch lived in Berlin. He had little contact with German painters, 'Berlin will not be a city of artists for long in any case,' he wrote home. It is clear that it was the social life in The Black Pig which kept him there and once the circle of friends began to split up he decided to make a break. In the autumn of 1895 he held a major one-man show at home in Kristiania, which was also attended by Henrik Ibsen. Ibsen was particularly preoccupied by the painting *Woman in Three Stages*, a painting which, according to Munch himself, was the inspiration for the subject of Ibsen's play *When We Dead Awaken*.

At the end of February 1896 Munch returned to Paris. He exhibited paintings at the Salon des Indépendants, firmly determined to make his mark as an artist in this cosmopolitan city. In the private Salon de l'Art Nouveau, he also exhibited his extended series of love motifs, and graphic works. In a fruitful partnership with the famous printer Auguste Clot, he created a number of colour lithographs and woodcuts with subjects from *The Frieze of Life*, and designed the playbills for the Théâtre de l'Œuvre's performances of Ibsen. But there was no real breakthrough in Paris. Munch's finances at this time were poor, particularly due to unsuccessful games of roulette. Once more he came into contact with August Strindberg, then in the middle of the Inferno Crisis. He also socialised with the poets Sigbjørn Obstfelder and Stéphane Mallarmé. Through his friend, the composer Frederick Delius, Munch came into contact with the Molard family who, in their home in the rue Vercingétorix, created a meeting place for artists.

Although Munch did not attain the expected breakthrough in Paris, the tide of public opinion began to turn back home in Kristiania. In the autumn of 1897 he held a major exhibition in Kristiania, and here he was able to see that his pictures no longer appeared quite so shocking to the public. Encouraged by good

Edvard Munch with his fiancée, Tulla Larsen c. 1899.

fortune, he rented studios in Universitetsgaten with the painter Alfred Hauge. He lived there too, sleeping on a mattress on the floor beside a smoking, smelly paraffin stove.

It was at this time that Munch became acquainted with Mathilde Larsen, daughter of one of the city's largest wine merchants. Tulla, as she was known, was already an 'old maid' of thirty. Munch was four years older and the relationship that began that winter was one from which neither would completely recover. Even at an early stage, it appears that the relationship was totally out of control as far as Munch was concerned, in that he completely underestimated the strength of Tulla Larsen's passion. In the spring of 1898 they travelled

together to Italy, where Munch studied the monumental art of the Renaissance, but soon he sent Tulla to Paris, to wait for him there. On Tulla Larsen's departure ,from Italy, however, the relationship was, in effect, over. Later they were together only sporadically until the relationship came to a dramatic close. In 1902 Edvard Munch and Tulla Larsen met for a 'reconciliation' in Åsgårdstrand. There was a revolver in the house and in a shooting accident Munch was wounded in the left hand. He blamed Tulla Larsen for the accident and subsequently broke off all contact with her and their set of friends, who he considered were on her side. Later Munch's concern about his hand almost amounted to monomania and his destroyed finger was a constant reminder of the 'three wasted years' of his life.

That same year, 1902, saw Edvard Munch achieve his definitive breakthrough in Berlin. Ten years after the 'scandal exhibition', *The Frieze of Life* was exhibited at the Berlin Secession, an exhibition which led to artistic recognition and financial success. 'It is all like an adventure,' he wrote home. He signed a contract with a German art dealer on the sole rights to sell his paintings and graphic work and, in the opthalmologist Dr. Max Linde from Lübeck, found his first patron. At the Salon in Paris, where Munch exhibited in 1903 and 1904, his pictures attracted considerable attention. His greatest success at this time, however, was the great exhibition in Prague in 1905. 'I hope that it brings not only Honour but also Gold,' he wrote hopefully to his aunt. Gold was not quite as abundant as he had hoped but all the same Munch looked back on that exhibition with great joy. He was grateful for the whole-hearted and magnificent reception he received and in later years he looked on those days in Prague as a 'beautiful dream'.

After the break with Tulla Larsen, however, Munch's nerves were on

The Frieze of Life at the Beyer and Sohn Gallery, Leipzig, 1903.

Edvard Munch in the garden of Max Linde in Lübeck, 1902.

Edvard Munch in his studio in Berlin, 1902. Photographic self-portrait.

edge. Constant travel and a high consumption of alcohol took their toll. Portrait commissions for the rich banker Warburg's daughter took him to Hamburg, where he suffered a series of hallucinatory attacks. Things were no better in Weimar, where his portrait commissions thrust him into a world of parties and receptions. As his nerves got worse, his aversion to Norway and the 'Town of the Enemy' increased. Munch convinced himself that he had to avoid returning home at any price, with the possible exception of short visits to Åsgårdstrand. After encouragement from friends in Germany he tried staying at spas in Thüringerwald, Bad Elgersburg and Bad Kösen, but failed to find peace and by 1906, when Munch was engaged by Max Reinhardt to design the set for a performance of *Ghosts* for the new intimate stage at Deutsches Theater in Berlin, his nerve problems were already severe.

Edvard Munch spent the summers of 1907 and 1908 at the bathing resort of Warnemünde on the Baltic, 'a German

Munch painting the portrait of Miss Warburg, Hamburg 1905.

Åsgårdstrand', as he christened it. He would set up his heavy canvases on the nudist beach and paint *Bathing Men* using lifeguards as models, while enjoying deep breaths of sea air. In September 1908, however, his stay was suddenly interrupted. Munch appears to have been on the verges of psychosis, he had the feeling he was being followed and believed that everyone was spying on him. He travelled to Denmark and with the help of his friend the poet Emanuel Goldstein he allowed himself to be admitted to Dr. Jacobson's clinic in Copenhagen. Here he found peace and quiet and also underwent various cures, including 'electrification'. He also vowed never again to drink alcohol. He continued his work while at the clinic and during the eight months he spent there he gained recognition on many counts. He was awarded the

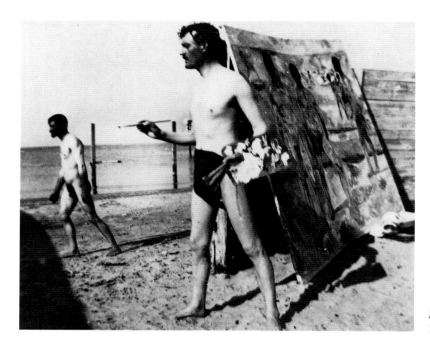

Edvard Munch painting on the beach in Warnemünde, 1908.

Royal Order of St. Olav for meritorious artistic activity and the National Gallery in Kristiania purchased many of the paintings in his exhibition in Kristiania in 1909, which was a success with the general public.

In May 1909 Munch was discharged from Dr. Jacobson's clinic. He decided to live in Norway but wished to avoid Kristiania at any price. As he saw it, that was where the 'enemy' lived. Together with his relative Ludvig Ravensberg, he travelled home by sea, his thoughts constantly on finding a place where he could settle down. When the ship passed the coastal town of Kragerø, he was so enchanted that he decided to make his home there. He rented a property with a large house and garden and a view over the archipelago. Here he had an open air studio built so that he could enter the competition to decorate the new hall, the Aula, of the university in Kristiania. He was inspired by the countryside and the people he met. The motifs for the main panels in the university decoration *History* and the centrepiece *The Sun*, are drawn from the natural surroundings of Kragerø, while the main figure in *History* was modelled on the sailor Børre Eriksen, who became Munch's handyman. 'Never has work given me so much pleasure,' he said.

It was a disappointment to Munch that he was unable to buy the house in Kragerø. The next year he therefore purchased a property on the other side of Oslo Fjørd, Nedre Ramme in Hvitsten. Here he found the landscape he sought for the other large picture for the

Edvard Munch painting Dr. Jacobson's portrait at the latter's fashionable clinic in Copenhagen, 1909.

By the easel in the streets of Kragerø, 1912.

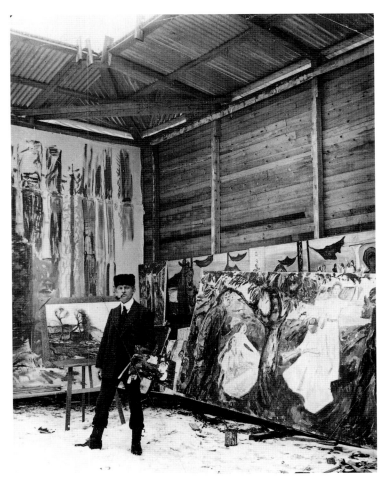

Edvard Munch in his outdoor studio at Skrubben, Kragerø, 1911.

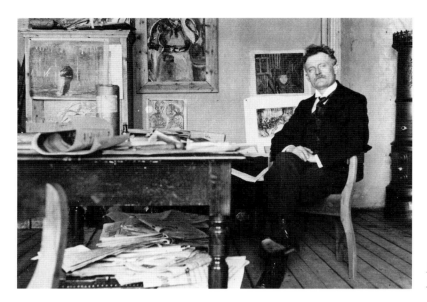

Edvard Munch in his study at Grimsrød Manor, 1913.

Aula, *Alma Mater*. In Munch's opinion, this property was in the most beautiful place on the coast and he stayed there with doves, turkeys, ducks and chickens, and his horse Rousseau pastured on the verdant grassy hills. In 1913 he also rented Grimsrød manor on the island of Jeløy for a few years, where he also had a studio built. His old aversion to Kristiania and its people also appeared to abate somewhat at this time, and now and then he ventured into the capital to visit the old haunts of his childhood.

At the Sonderbund exhibition in Cologne in the spring of 1912, Munch had the great honour of being invited to exhibit with van Gogh, Gauguin and Cézanne. 'Here are gathered the Wildest things

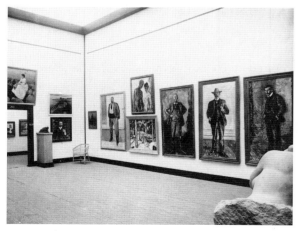 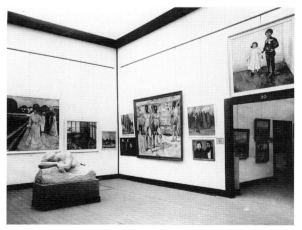

Edvard Munch exhibits at the famous Sonderbund exhibition, Cologne 1912.

Ekely

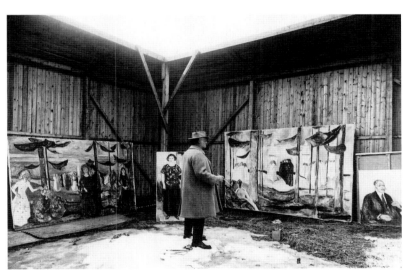

Edvard Munch painting in his outdoor studio at Ekely, c. 1923.

painted in Europe – I am a pure classicist and faded…', he wrote to his friend Jappe Nilssen. And the next year Munch and Picasso, as the only foreigners invited, were each given their own room at the Autumn Exhibition in Berlin.

1916 saw the inauguration of the Aula at the university and the same year Edvard Munch bought the property at Ekely in Skøyen, west of Kristiania. Here he was to settle for the rest of his life. The main house at Ekely was a roomy villa in Swiss style. A glass veranda on the south side looked out onto a splendid orchard with apple and cherry trees. From the veranda, one could see for miles, towards the south the

landscape opened out towards the town and the fjord and in the west there was a view of far off mountains. When Munch bought the property it included an old barn and besides the horse and the dogs, for a while he also kept cows in the cowshed and pigs in the sty. Hens were also part of the 'farm'. At that time Munch was a prosperous man and liked to look the 'landowner'. He had several outdoor studios built and, in addition, in 1919 a 'winter studio' designed by his friend and relative the architect Henrik Bull.

Edvard Munch lived in relative isolation at Ekely, and had less contact than before with friends and family. His travelling fell off too, but in 1920–1922 he visited Berlin, Paris and Zürich, and in 1926-27

Edvard Munch in front of the veranda at Ekely, 1926.

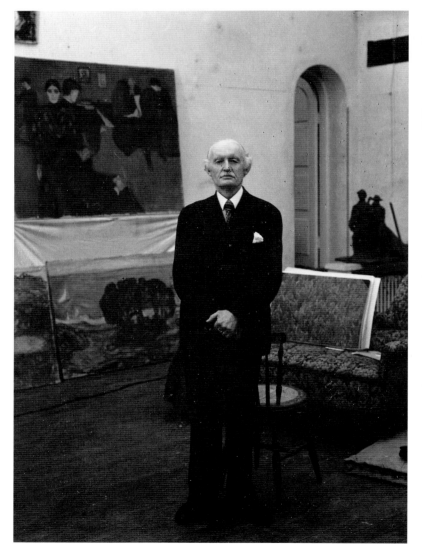

Edvard Munch, 75 years old in his winter studio at Ekely, 1938.

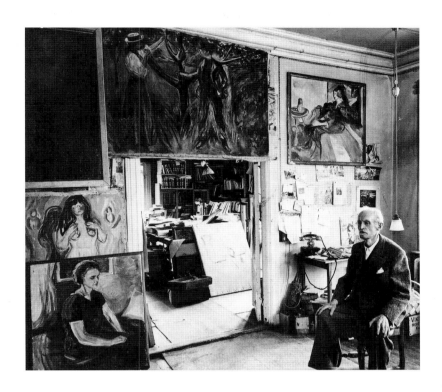

Edvard Munch in his study at Ekely, probably taken in December 1943, a month before he died.

he once more travelled to several European cities. The Munch exhibitions around Europe were like a 'triumphal procession without like', as Jappe Nilssen put it, and in 1927 major retrospectives of Edvard Munch's art were held in Berlin and Oslo. However, the painter himself steered clear of the 'opening fuss'. He had more important things to do: 'I can no longer stand being away from charcoal and paintbrushes for long. I must know that if the urge comes rushing through me the charcoal and brushes will be ready.' In 1930 a blood vessel burst in Munch's right eye. He was almost blind for a while and three years later he again suffered what he himself called 'dangerous eye congestion'.

On his 70th birthday in 1933 Munch was awarded the Grand Cross of the Order of St. Olav. When German forces invaded Norway in 1940, Munch refused all contact with German and Norwegian Nazis. The occupation powers threatened to seize Ekely, and Munch feared for his 'children' – his pictures. But at the same time he felt a strange peace. '...now all the old phantoms have crept down in their mouseholes for this one enormous phantom,' he is said to have said to Pola Gauguin, the artist's daughter. In the winter of 1943/44 Munch contracted pneumonia and he died peacefully at Ekely on 23 January 1944.

EDVARD MUNCH AS A PAINTER

by Arne Eggum

*T*HE SCREAM IS WELL ESTABLISHED as the epitome of Munch's work as an artist. The painting, which seethes with movement, appears to be painted with an explosive force and the result is a genuine expression of an agitated mind. It has become recognised as the actual mental image of the existential *angst* of civilised man. With this motif, Munch departs from the central perspective field on whose stage painting had been played out since the Renaissance. In *Philosophie der Kunst*, Schopenhauer claimed that the limit of the power of expression of a work of art was its inability to reproduce a scream, 'das Geschrei', precisely the title which Munch was to give his motif. He appeared almost to have wished to correct the claim of the philosopher, and his solution of the problem rests on contemporary theories of synaesthesia, where light and colour impulses can produce an impression of sound, and vice versa.

A gouache in the Munch Museum, dated 1892, shows Munch experimenting, finding his way towards the final form of the picture. Here, Munch has also written one of his many versions of the lyric prose text associated with the motif:

I was out walking with two friends – the sun began to set – suddenly the sky turned blood red – I paused, feeling exhausted, and leaned on the fence – there was blood and tongues of fire above the blue-black fjord and the city – my friends walked on, and I stood there trembling with anxiety – and I sensed an endless scream passing through nature.

Other artists at the turn of the century such as Félicien Rops, Fernand Khnoppf, Gustave Moreau and James Ensor were also striving towards a personal basis for their art, but none developed such a uniquely 'private' symbolism on the basis of personal traumatic experience. He had the courage to expose his own life situation to view – denuded of any self-pity. In Jungian terms, he crystallises archetypal images and symbols of human existential experience, and he takes this

Despair, 1892
Fortvilelse
Charcoal and gouache
370 x 422 mm (14 ¾ in x 16 ¾ in)
T 2367

The Scream, 1893
Skrik
Oil on board
83.5 x 66 cm (32 ¾ in x 25 ⅞ in)
M 514

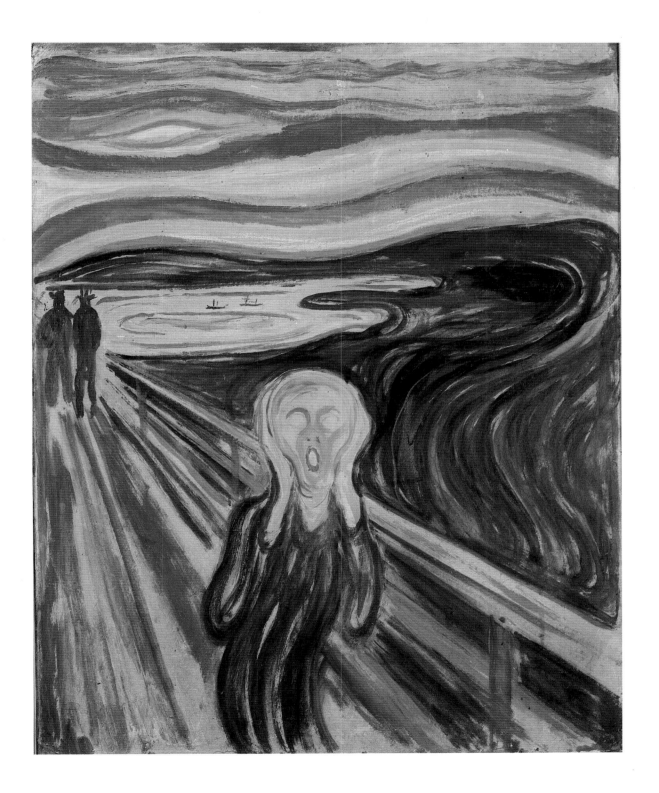

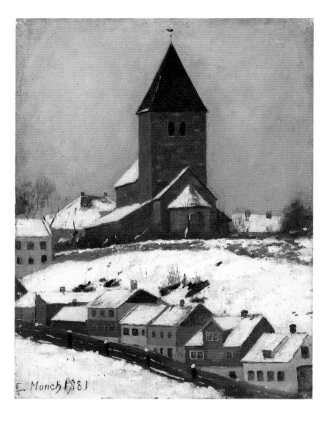

Old Aker Church, 1881
Gamle Aker Kirke
Oil on board
21 x 16 cm (8 ¼ in x 6 ¼ in)
M 1043

In November of 1880, the 17-year-old Edvard Munch noted in his diary: 'My decision is now namely to become a painter.' That same winter the young artist painted old Aker Church for the first time, in a nuanced study. The church, which towers above the row of houses, also gives the motif a certain monumental sense.

crystallisation farthest in *The Scream*, where the almost abstract figure in the foreground makes concrete and personifies the existential *angst* of modern man. This is Expressionism as Munch saw it: an extremely subjective, existential art, retaining something original and primitive, which caused one of his friends in Berlin in the 1890s to write with reference to Gauguin: '…he does not need to travel to Tahiti to see and experience the primitive in human nature. He carries his own Tahiti inside himself…'

1880 – when Munch decided to become a painter – saw a marked revolution in the focus of Norwegian art. The Norwegian artists, who had previously been trained abroad, first in Germany and later in France, now returned to Norway and proclaimed Naturalism as the only possible direction for young Norwegian art. This implicitly meant saying farewell to the demand for rigid academic training and to the German focus in Norwegian art, and instead a turning to the artistic environment of Paris. Naturalism, with its basis in studying nature, resulted in the conviction that, instead of formal training, it was necessary for young artists to learn from nature by painting directly from it or from a model.

Tête-à-tête, c. 1885
Tête-à-tête
Oil on canvas
65.5 x 75.5 cm (25 ¾ in x 29 ⅝ in)
M 340

The man turning towards the smiling young woman with the whisky glass before her is the only preserved painting from the 1880s which has clear erotic undertones. The rich and varied treatment of the gloomy atmosphere in paint takes on an intrinsic value in this work.

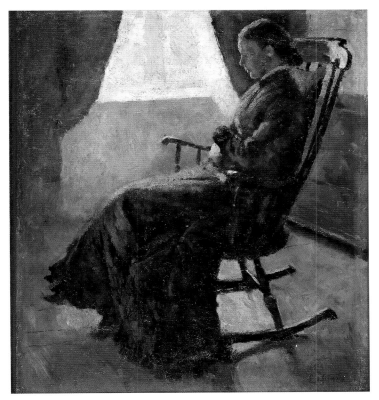

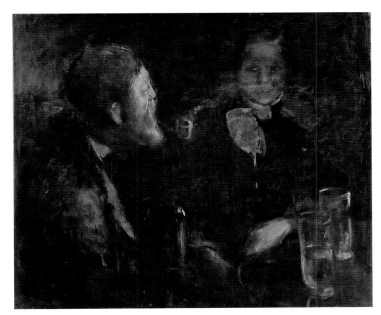

Aunt Karen in the Rocking Chair, 1883
Tante Karen i gyngestolen
Oil on canvas
47 x 41 cm (18 ½ in x 16 ⅛ in)
M 1108

Aunt Karen in the Rocking Chair is one of Munch's earliest works, which bears witness to his skill in psychological and expressive painting. It transcends its portrait-like setting as a purely atmospheric picture. The contrast between the darkness inside and the light outside is a tool Munch was to use in a number of motifs later in life.

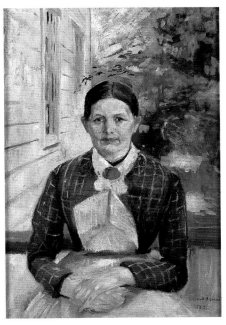

Karen Bjølstad, 1888
Oil on canvas
82.5 x 81.5 cm (32 ⅜ in x 32 in)
M 1057

In the portrait of Munch's aunt we see a combination of portraiture and the outdoors which is unusual in Munch's art. The straight-backed woman is lit from behind, sitting bathed in the reflections from the sun. Against the verdant natural environment she appears as the monolithic support she was for the family.

That same year, Emile Zola defined Naturalism as 'a corner of nature seen through a temperament'. Munch's art in the first half of the 1880s can be seen as a radicalisation of this idea, since he emphasises the artist's emotional experience of the motif. With *The Sick Child* (first version 1886, National Gallery, Oslo, fig.1), Munch develops the subjective and the existential aspect, in that he primarily wishes to create an expression of the painful feelings associated with his memories of his sister Sophie's illness and death. However, according to Munch himself, the motif also symbolises memories of his dying mother and his own fear of death when ill as a child: '…I am convinced that there is hardly a painter who drained his subject to the very last bitter drop as I did in *The Sick Child*. It was not only I myself sitting there — it was all my loved ones.'

Paintings of sickbeds were very common in the naturalistic epoch, but Munch's depiction of a young person's farewell to an un-lived life displays great psychological sensitivity and is so expressive and strikingly innovative that it can hardly be thought to have been created without the artist having formulated the rudiments of an existential expressionistic aesthetic, at least in his own mind.

In *The Sick Child*, Munch appears to exceed the limits of what could be expressed in a naturalistic language of form. Expressing strong, subjective feelings required another form of expression. According to Munch himself, he repainted the picture 20 times before finally exhibiting it. The painting displays the artist's nervous search with brush and palette. Due to its pronounced unfinished character, he exhibited the painting as *Study*. Later in life he said that this experiment bore the seeds not only of central works of his own, but also of problems which were to occupy several styles of art in the 20th century. He himself would later term it 'a thoroughly nervous, constructed (cubist) and colourless picture'.

The shocking effect the painting had when Munch exhibited it at the Autumn Exhibition in Kristiania in 1886 is unique in Norwegian art history. A storm of indignation and protest broke out. At the opening people crowded around in front of the painting and laughed, and in the press it was described as 'an abortion' and 'fish stew in lobster sauce'.

A journey to the World's Fair in Antwerp in 1885, followed by a visit to Paris, brought Munch into direct contact with the latest movements in European art. His brush strokes became freer and broader, and he combined Impressionistic and Naturalistic elements in what was, for the time, a daring manner.

In the following years, Munch was constantly the victim of

**Fig 1. The Sick Child, 1886
Det syke barn**
Nasjonalgalleriet, Oslo.
Photograph taken in 1892/93 before the picture was painted over.

derisive and uncomprehending criticism in the press, although artist colleagues discovered his astonishing ability at an early stage and considered him an exceptional, if somewhat undisciplined, talent.

In April 1889, Munch – then 25 years old – arranged his first one-man show at the Student Association in Kristiania, where he exhibited 63 paintings and a large number of drawings. For a young and controversial artist to exhibit his collected works was something completely unknown, and according to the press, demonstrated a 'high Degree of Boldness and a lack of Self-criticism'. However, Munch's teacher, or more accurately mentor, Christian Krohg, wrote an enthusiastic article which included the statement: 'He paints things, or rather he sees them, differently from other artists. He only sees what is essential and needless to say that is all he paints too… it is precisely that which puts Munch ahead of his generation: he really grasps how to show what he feels, what has him in thrall and he subordinates everything else to that.'

The same year Munch received his first state scholarship, and, with it in his pocket, in the autumn he headed to Paris. It is likely that even before he travelled to Paris Munch had begun an illustrated 'journal', which was probably inspired by the message from Kristiania bohemia on 'writing one's own life'. The central figure of Kristiania bohemia, author and nihilist Hans Jaeger, claimed that one had to strive for honesty – ruthless honesty. One was to live truthfully – existentially truthfully. There was a religious aspect to this attitude, where the central inspiration was considered to be the Christian poet and philosopher Søren Kierkegaard. Munch's journal bears the seeds of the idea of a personally-focused, autobiographical art, what was later to develop into a number of the main motifs in what is known as his *Frieze of Life*. The book contains tragic memories from childhood, impressions of bohemian life in Kristiania, and the experience of his first great love, as well as the rudiments of a personal theory of art:

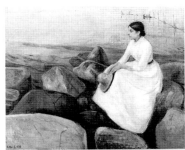

Fig 2. Evening/Inger on the Shore, 1898
Inger på stranden
Rasmus Meyers Samlinger, Bergen.

The fact is that at different times you see with different eyes. You see differently in the morning from in the evening. The way in which one sees also depends on one's mood… If, in the morning, you come from a dark bedroom into the living room, then you might see everything in a blue light. Even the deepest shadows have a light atmosphere above them. After a while you get used to the light and the shadows get deeper and you see more sharply. If you are to paint such an atmosphere … you cannot merely sit and stare at everything and paint it 'as accurately as you see it'. You must paint it as it appeared when the motif seized you.

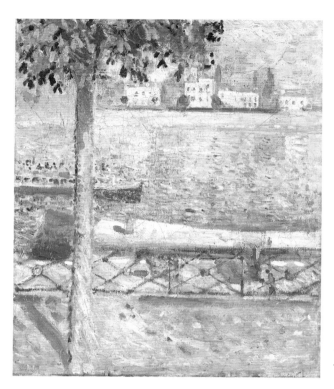

The River Seine by St. Cloud, 1890
Seinen ved St. Cloud
Oil on canvas
46.5 x 38 cm (18 ¼ in x 14 ⅞ in)
M 1109

In 1890 Edvard Munch was living in St. Cloud outside Paris, where he painted the Seine from different angles and at different times of the day. Many experiments from this time demonstrate a desire to assimilate various trends in French avant-garde art and liberate himself from the traditions of Norwegian painting.

From the Shore in Nice, 1892
Fra stranden i Nice
Oil on canvas
46.5 x 69 cm (18 ¼ in x 27 ⅛ in)
M 1076

In 1891 and 1892 Munch spent several months in Nice and the countryside around the town proved a new source of inspiration. He experimented further with impressionistic, pointillist techniques, which gives the pictures a light, summery feel. The shoreline in Åsgårdstrand here gains a fresh, French equivalent using large blocks of colour.

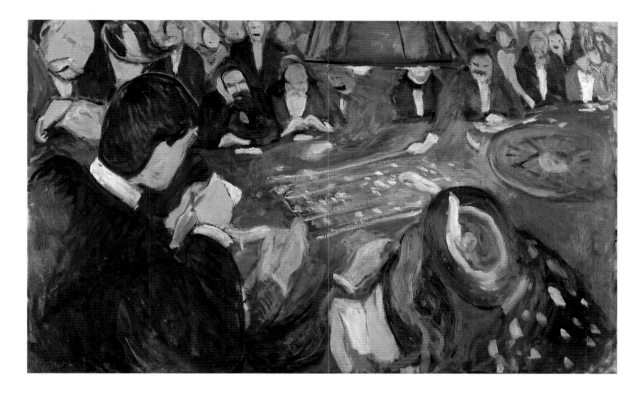

At the same time as Munch left for Paris, he exhibited at the Autumn Exhibition the painting *Summer Night* (fig.2), later called *Inger on the Shore* (1898, Rasmus Meyer Collection, Bergen) – once more, a painting which was so different and innovative that the public and the critics were unable to understand it. The woman in white who sits alone on the shore on a calm summer night, is depicted with a sweeping, almost formulaic line, and the blueish melancholy landscape appears to reflect her own mood. The pale and dry, but still glowing, colour tones of the painting and the frozen, but lyrical expression, indicate that Munch, like so many of the important painters of the time, was influenced by the art of Puvis de Chavannes. The motif comes from the small coastal town of Åsgårdstrand, to which Munch was to return summer after summer throughout his life.

Once in Paris, Munch dutifully enrolled as a pupil with the influential but conservative portrait painter, Léon Bonnat, who held a large class for Scandinavian painters. Munch remained there for a couple of months, as long as it took to make his mark as one of the most gifted of the pupils, until one day he painted a nude against a background as he saw it, green rather than red, as it undoubtedly was, and as Léon Bonnat saw it. Thus Munch provoked an

By the Roulette, 1892
Ved ruletten
Oil on canvas
74.5 x 115.5 cm (29 ¼ in x 45 ⅜ in)
M 50

In Nice Munch also worked with motifs from the gambling tables of Monte Carlo. The casino - which he described as 'an enchanted castle - where the Devils meet -' was an Eldorado for extreme psychological situations. The formal means are clearly inspired by Gauguin and his circle.

argument, left the school and settled in St. Cloud, on the edge of Paris. Here he painted the Seine outside his windows in varying lights throughout the winter and spring, in order to study, through his own work, the language of form of the Impressionists, although more by ear than by the book. No other Norwegian – nor Scandinavian – painter was so closely linked with Impressionism in this period as Munch. For example, the Norwegian press at that time referred to him as Bissarro, with reference to Pissarro. Munch, however, considered that the demands of the Impressionists to reproduce the actual impression of the moment, in principle, is impossible. In the final instance impressionism becomes an art of memory. As Munch himself expressed it: 'I do not paint what I see but what I saw.'

Fig 3. Night, 1890
Natt
Nasjonalgalleriet, Oslo.

The main work from the winter in St. Cloud, however, is *Night* (fig.3) (1890, National Gallery, Oslo). The monochrome, blueish colouring is reminiscent of James Whistler, and the expressive use of space has roots in the art of van Gogh. The highly reflective and melancholy features of the painting are partly caused by the tension between the life outside and stillness inside. The model is Munch's friend Emmanuel Goldstein, but undoubtedly represents Munch himself. In the otherwise empty room, we see the suggestive shadow of the cross of the window fall across the floor. The picture recalls Munch's notes about the relationship between winter and loneliness. His father's unexpected death in December shook him on many levels and stimulated his literary activity. Among other things he writes: 'I lead my life in the company of the dead – my mother, my sister, my grandfather and my father – above all with him – all the memories – the smallest of details, return to me.'

It was also in his grief over his father's death that Munch here in St. Cloud composed what was later called the St. Cloud Manifesto. The 'Manifesto' tells how Munch on a night out in Paris had a vision of painting a series of pictures of 'sacred, powerful moments', a vision which was to be linked to the notes in his literary journals and which was to find shape some years later in his artistic masterwork, *The Frieze of Life*.

At home in Norway in the summer of 1891 he was to experiment in an entirely new language of form. Munch's first simplistic, synthetic work of art, *Melancholy* (fig.4) (prob. 1891. Priv. Coll.) arises alongside Gauguin's art, Maeterlinck's dramas and French symbolist poetry. The melancholy figure in the foreground is right at the front of the picture, while the couple on the bridge in the background can be seen as part of the mental image of that melancholy figure. The forms

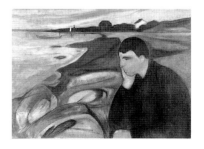

Fig 4. Melancholy, prob. 1891
Melankoli, Priv. Coll.

are synthetically kept together in large planes, delimited by clear contours. The long curving shoreline expresses the empty and desolate feeling of the melancholy figure. The motif goes back to Munch's friend Jappe Nilssen, who that summer suffered the anguish of jealousy in a three-way relationship with Christian Krohg and his wife Oda Krohg. His friend's despair reminded Munch of his own sorrow in connection with an unsuccessful relationship with a married woman six years earlier. The painting becomes an expression of Munch's subjective suffering through alter ego, which he crystallises into a symbol of general melancholy.

When *Evening/Melancholy* was exhibited at the Autumn Exhibition, it was first overlooked by the critics. Christian Krohg then produced a long, enthusiastic article in the press which only discussed this one picture. He finds it 'serious and strong – almost religious … related to Symbolism – the last movement in French art'. And he says that the picture has so musical an expression that Munch should be awarded a composer's pension.

In the following years Munch's scholarship was renewed and he returned to France, clearly working in return for the funding he received but on his own terms. Each year he sent sensational, modern paintings home for the Autumn Exhibition and it was in Nice in 1892 when visiting his painter friend Christian Skredsvig that he produced what he himself referred to as 'his first Scream', today known by the title *Despair* (1892) (Thielska Galleriet, Stockholm). Christian Skredsvig describes how the painting came into being.

For a long time he had wanted to paint his memories of a sunset. Red like blood… 'He is yearning for something impossible and his religion is despair,' I thought but advised him to paint it – and he painted his remarkable Scream.

Edvard Munch's breakthrough as a great individualist in European art came in the form of what was known as the 'scandal exhibition' in 1892. A Norwegian painter, resident in Berlin and secretary of the Artists' Union there, had seen a major one-man show by Munch when travelling through Kristiania. The exhibition can be seen as a desire on Munch's part to present his domestic public with the results from his scholarship, together with previous work. The secretary of the Berlin Artists' Union had Munch invited to exhibit in the Union's premises in Berlin. In the advance press Munch's paintings were referred to as 'pictures of an Ibsenesque mood', arousing curiosity both on a social and psychological level.

Self-portrait under the Mask of a Woman, 1891-92
Selvportrett under kvinnemasken
Oil on canvas
69 x 43.5 cm (27 ⅛ in x 17 ⅛ in)
M 229

The rigid, frontal pose which Munch uses in this self-portrait is one of which there are few examples in portraits outside Symbolism. This is the artist's first deliberately psychological self-portrait, where he stares anxiously ahead below the demonic mask of a woman.

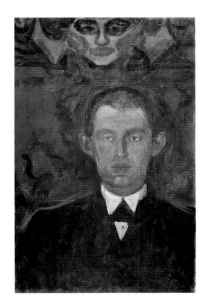

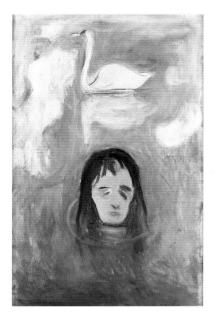

Vision, 1892
Visjon
Oil on canvas
72 x 45 cm (28 ¼ in x 17 ⅜ in)
M 114

Vision is one of the more exaggeratedly symbolic paintings that Munch completed in the 1890s. It shows the head of a man rising out of the water, behind his head glides a swan, the symbol of art. There are a number of fragments of text in Munch's hand linked to this motif, including 'I lay in the mud and among crawling things and slime – I longed to reach the surface – I had my head above water – I saw the swan – it's shining whiteness – the pure lines I longed for...'

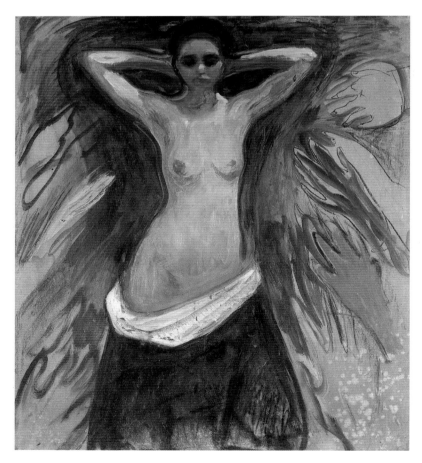

Hands, 1893
Hendene
Oil and crayon on cardboard
91 x 77 cm (35 ¾ in x 30 ¼ in)
M 646

It is likely that this motif is based on applause for a cabaret prima donna. With simple techniques and the fewest possible details, however, Munch crystallises the motif into a universal expression of primitive, masculine desire.

Stanislaw Przybyszewski, 1895
Tempera on board
62 x 55 cm (24 ⅜ in x 21 ⅝ in)
M 134

The portrait of Stanislaw Przybyszewski, where the Polish author is seen severely facing front with a cigarette dangling from the corner of his mouth, has been described as 'an unset pearl'. The picture is unusually expressive and the formal elements are depicted with extreme simplicity.

Dagny Juel Przybyszewska, 1893
Oil on canvas
148.5 x 99.5 cm (58 ⅜ in x 39 ⅛ in)
M 212

The portrait of Dagny Juel is without doubt one of the key works in Munch's portrait art. She stands in the centre of the painting in a dark blue dress with her hands behind her back against a shimmering blue atmospheric background. The face with its furtive smile — lit from an undetermined light source — lifts towards the observer.

Since the war between Germany and France of 1870/71, artistic life in Berlin and Paris had polarised. While Paris was opening up to a mass of new impulses, Berlin was isolating itself around the idea of an ideal, educational national art and Munch's exhibition was exploited in this schism. On the opening day the respected grandees of the Union, headed by the conservative painter Anton von Werner, demanded that the premises should be closed to the public on the grounds that it was immoral to show such degenerate art. The canvases were not even properly stretched! This was an insult to the middle-class public in the imperial capital. The press referred to

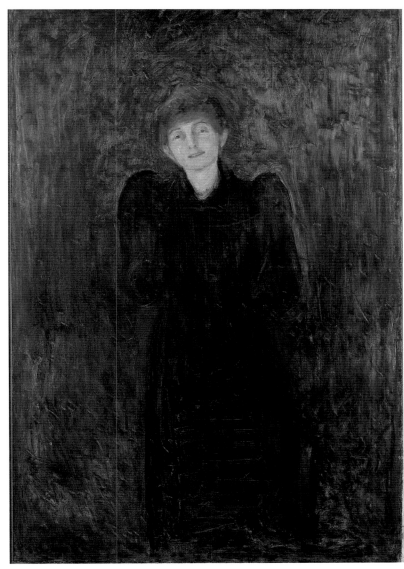

Munch as the epitome of a gifted 'German' artist who had let himself be influenced by decadent French taste and the result was 'anarchic daubs'. The event made Munch famous, or rather notorious, overnight and in the press was described as 'Der Fall Munch' – the Munch Affair.

Munch, however, greatly enjoyed the scandal, and was surprised that something as innocent as art could cause such an uproar. The exhibition toured to Düsseldorf and Cologne, reopening in Berlin in December the same year. He sold almost nothing, but earned a respectable income from ticket sales. Everybody wanted to see an international scandal!

In Berlin Munch quickly became integrated in the circle of literati and artists around August Strindberg and the Polish author Stanislaw Przybyszewski, who often met in the wine bar 'Zum schwarzen Ferkel' (The Black Pig). The environment appears to have acted as a catalyst for Munch, and undoubtedly had great significance in terms of the emphasis Munch was to place on content – what had been subjectively experienced – in his art. A characteristic feature, however, is that the autobiographical aspect of his art is always free of self-pity. It is likely that it was here, in this world of literature, that he realised the sources he had at hand in his own literary journals. Munch himself pointed out in several contexts that he had 'written' *The Frieze of Life* before he formed it visually.

The Voice/Summer Night, 1893
Stemmen/Sommernatt
Oil on canvas
90 x 118.5 cm (35 ⅜ in x 46 ⅝ in)
M 44

There are two painted versions of The Voice, one in the Museum of Fine Arts in Boston, the other in the Munch Museum. The first version was exhibited in Berlin in 1893 as the first picture in a series jointly entitled Study for a Series: Love. These love motifs were the first works in what would later be known as The Frieze of Life.

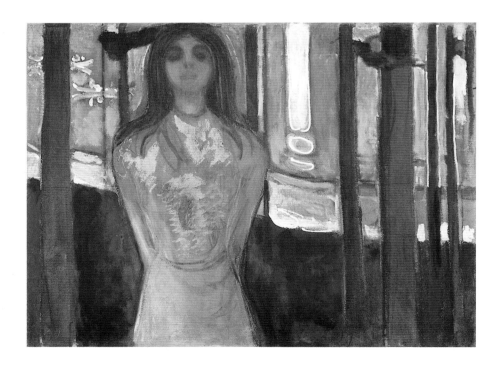

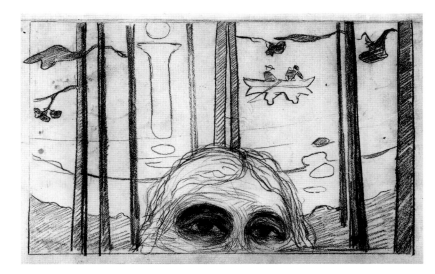

Eyes/The Voice, 1893-96
Øynene/Stemmen
Pencil and crayon
415 x 500 mm (16 ¼ in x 19 ⅝ in)
T 329

*The Munch Museum holds a number of
sketches for the motif The Voice. This
drawing bears the inscription:*

Your eyes are as large as the semi-
circle of heaven when you stand near
me and your hair is full of gold dust
and your mouth I do not see – see only
that you smile.

Eye in Eye, 1894
Øye i øye
Oil on canvas
163 x 110 cm (64 ⅛ in x 43 ¼ in)
M 502

*Here we see the very first of Munch's
many versions of the Adam and Eve
theme. The house in the background is
naive in design, which emphasises the
adolescent features of the pair and at the
same time contributes to expressing
awakening, erotic tension.*

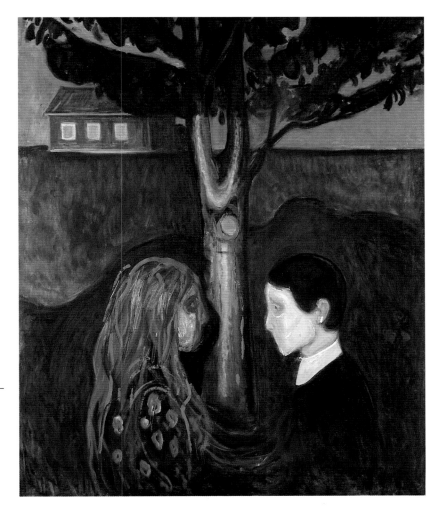

Separation, 1896
Oil on canvas
96.5 x 127 cm (37 ⅞ in x
50 in)
M 24

*The young woman in the light
dress stands looking out over
the sea while her hair stretches
like threads towards the head
of the man turned away from
her. He clutches at his heart
with a bloody hand; the artist
has to choose between
art/suffering and earthly love.
The art nouveau lines in this
version of the motif indicate
that the style was influenced
by the work on the lithograph
of the same motif, carried out
at the same time.*

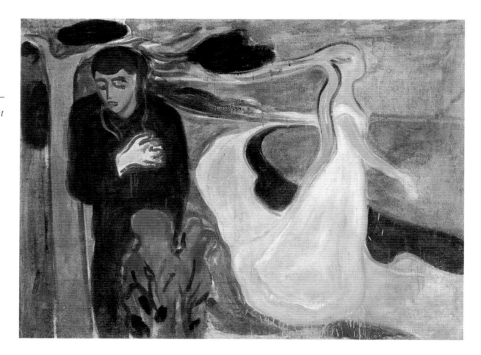

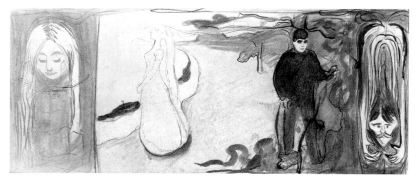

**Girl with Heart/Separation,
1895–96**
Piken med hjertet/Løsrivelse
Pencil, water colour and Indian ink
205 x 260 mm (8 in x 10 ⅛ in)
T 337

*This drawing, which has Separation as its
main motif, works further on the
symbolism of the hair. In the left side
panel the woman's hair falls down and
encircles the man's heart. On the right the
woman's long hair is the central feature; it
hangs threateningly over the man's head
merging into hands which grip the man's
breast. The drawing is also an example of
how Munch groups his motifs together
symbolically.*

Gradually a stronger emotional content now begins to appear in
his work, inspired by the surroundings in Åsgårdstrand where he
spent the summers. Pictures such as *Starry Night, The Voice, Red and
White* and *Separation* are filled with a suggestive and erotic natural
mysticism, often conveyed by using depth and blue tones and long
melancholy, rhythmic lines which reflect the curving edge of the
shore; works where one can sense the influence of Whistler, Böcklin,
van Gogh and Gauguin.

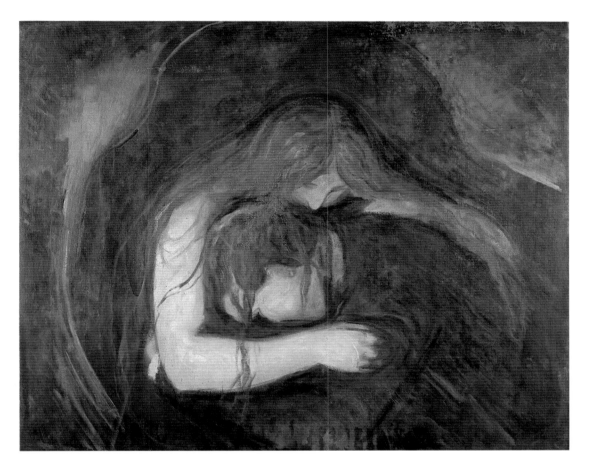

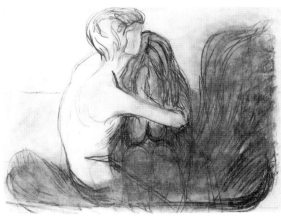

Consolation, 1894
Trøst
Charcoal
479 x 630 mm (18 ⅞ in x 24 ¾ in)
T 2458

Vampire, 1893–94
Vampyr
Oil on canvas
91 x 109 cm (35 ¾ in x 42 ⅞ in)
M 679

The motif is simple and concentrated in expression. A woman with long red hair bends over a man; Medusa-like she lets her red hair bind him to her. The pair cast a single shadow, which groups them in a classic pyramid composition. Love and Pain, which was the first title of the motif, indicates an ambition to express complex feelings in painting.

A comparison of Vampire and Consolation shows how Munch varies the theme of love and pain in almost opposing ways. The drawing is probably the basis for a graphic work of the same year. The motif was first expressed as a painting in 1907.

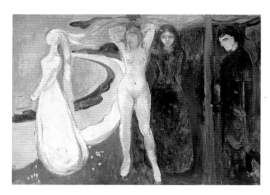

The Woman/Sphinx, 1893–94
Kvinnen/Sfinx
Oil on canvas
72.5 x 100 cm (28 ½ in x 39 ¼ in)
M 57

The Woman/Sphinx has been seen as a preliminary study to the main work held in the Rasmus Meyer Collection in Bergen. However, it has a language all of its own with strong colourist features indicative of Munch's future art. The three women are associated with various sides of the nature of woman – as Munch saw it – and to the cycle of life: youth, maturity and old age.

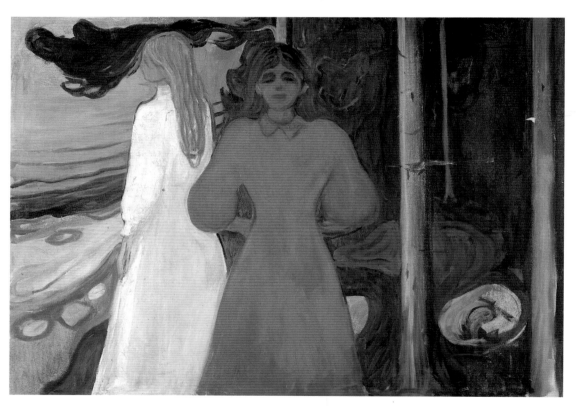

Red and White, 1894
Rødt og hvitt
Oil on canvas
93 x 125 cm (36 ½ in x 49 ⅛ in)
M 460

In terms of motif, Red and White is related to The Woman/Sphinx, but instead of the naked and challenging female figure of that picture, in Red and White the central woman is dressed in strong red – the colour of love. The painting was also painted over at a later date. To the right between the trees a dark figure can still be distinguished.

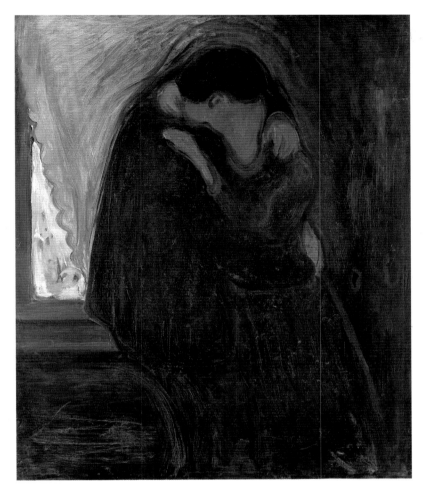

Kiss, 1897
Kyss
Oil on canvas
99 x 80.5 cm (38 ⅞ in x 31 ⅝ in)
M 59

*Munch painted a number of variations of
the motif Kiss, placing the couple in
various positions but always expressing
the tension between life rushing past
outside and the timeless, frozen moment
inside. In this version Munch explores the
effect of back lighting, which contributes
to the abstract, surface-like nature of the
couple whose bodies glide across each other
into a single shape.*

'Adieu', 1889-90
'Adjø'
Pencil
270 x 208 mm (10 ⅝ in x 8 ⅛ in)
T 2356

*The contrast between outdoors and indoors in Kiss can already be
seen in this small pencilled drawing from 1889-90. The details in
the drawing, such as the empty easel and the gas lamp outside
indicate that Munch is depicting something he himself experienced.*

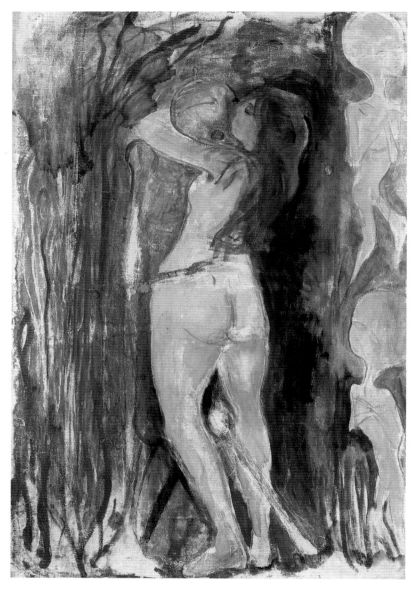

The Face of a Madonna, 1894
Madonnas ansikt
Charcoal and pencil
615 x 471 mm
T 2449

This study of the Madonna was used by
Stanislaw Przybyszewski for the jacket
of his book The Vigil, published in
1894, where the narrator, a painter who
borrows many features from Edvard
Munch, surrounds himself in his studio
with images of female figures from
mythology and religion.

Madonna, 1893–94
Madonna
Oil on canvas
90 x 68.5 cm (35 ⅜ in x 26 ⅞ in)
M 68

The aura-like lines around the model in
this main motif from The Frieze of Life
which ripple in a soft and suggestive
rhythm, the half closed eyes and the
deep-set eyes allow us to sense the ecstasy
of conception, the pinnacle of love but
also an underlying pain. The red colour
of the halo has associations with both
love and blood.

The Girl and Death, c. 1893
Piken og døden
Oil on canvas
128.5 x 86 cm (50 ½ in x 33 ¾ in)
M 49

The Girl and Death is one of the many motifs in the history of art of the Dance of Death.
Munch depicts the naked woman in her full, sculptural physicality, while the man is reduced
to a skeleton. The woman appears to be sucking out the man's heart and leaving him an
empty shell.

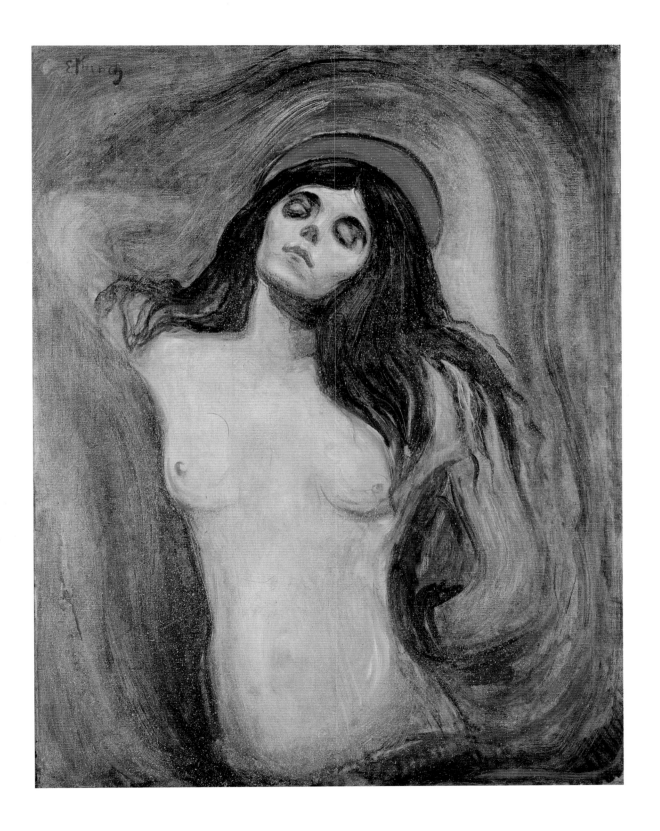

In a restricted sense, *The Frieze of Life* covers a number of main motifs in painting of the 1890s which was exhibited as a frieze around all four walls of the Berlin Secession in 1902 under the composite title: *A Series of Pictures from Life*. Each of the four walls had its own title: the left-hand wall was called *Love's Awakening*, and included the pictures *Red and White, Eye in Eye, Kiss* and *Madonna*.

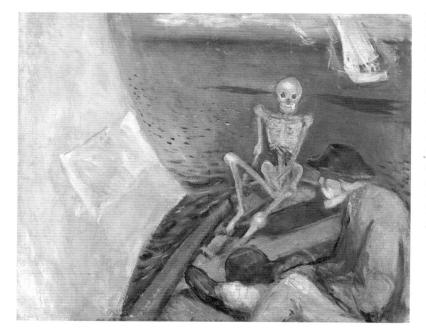

Death at the Helm, 1893
Døden ved roret
Oil on canvas
100 x 120.5 cm (39 ¼ in x 47 ⅜ in)
M 880

The old man in the boat with death at the helm has many features in common with Munch's other depictions of his father. The motif was first produced as a counterpart to the similarly bitter, almost repulsive The Dead Mother, which may indicate that Munch wished to represent his father and his mother's death as a diptych.

The Dead Mother, 1893
Den døde mor
Oil on canvas
73 x 94.5 cm (28 ⅝ in x 37 ⅛ in)
M 516

The brutal image and the noxious colours repel the observer in the same way as Munch, at five years old, must have felt repelled by his mother on her bier. The radiant spring landscape which can be seen through the window contrasts with the feeling of death otherwise conveyed by the motif.

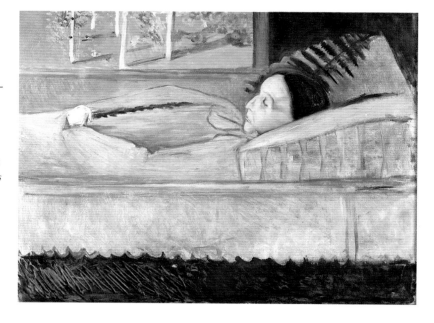

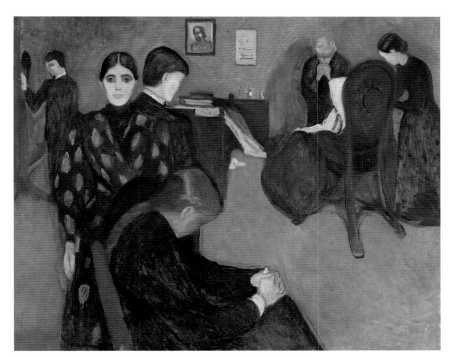

Death in the Sick Room, 1893
Døden i sykeværelset
Oil on canvas
134.5 x 160 cm (52 ⅞ in x 62 ⅞ in)
M 418

Death in the Sickroom goes back to the memory of the death of Munch's beloved sister, Sophie. Otherwise the models are depicted at the ages they were when the motif was painted, not their ages when the event took place. Here Munch may have wished to express a dimension of contemporaneousness – demonstrating that the family would always be affected by Sophie's death.

Death in the Sickroom, 1893
Døden i sykeværelset
Charcoal and pencil
350 x 460 mm (13 ¾ in x 18 in)
T 2380

This pencil drawing appears to be the direct starting point for the Munch Museum's painted version. In the painting, however, Munch has introduced a couple of new elements: the print of the head of Christ above the bed, which otherwise has points in common with a similar print from his childhood home, a painting above the bedside table and the basin under the bed.

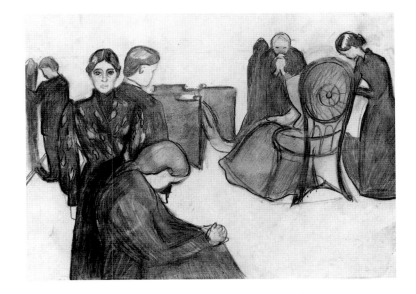

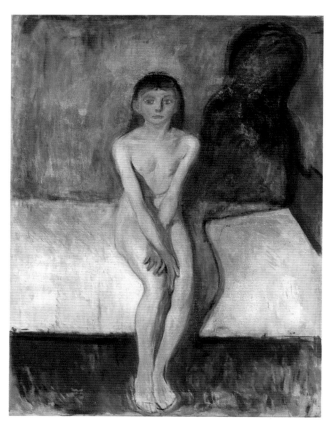

Puberty, 1893
Pubertet
Oil on canvas
149 x 112 cm (58 ⅜ in x 44 in)
M 281

The motif, with the young, naked girl with her rigid blocked eyes and hands pressed between her knees, appears – in its frozen, vertical position – to be locked into the horizontal line of the bed. Her shadow towers threateningly against the wall behind her, contributing to the feeling of loneliness and anxiety. It is an image of awakening anxiety about life, which is linked to awakening sexuality.

On the next wall hung pictures characterised as *Love Blossoms and Dies*, including *Ashes, Vampire, Jealousy, Sphinx* and *Melancholy*. Then came *Fear of Life*, where we find *The Scream, Anxiety and Red Virginia Creeper*, and on the final wall hangs *Death* with pictures such as *Death Struggle, Death in the Sick Room, The Girl and Death* and *The Dead Mother and Child*. Munch himself referred to the frieze as 'a poem of love, anxiety and death' and said that with these pictures he wished to 'explain life and its meaning – [and] help others to clarify their lives.'

This time Munch was discussed widely in the German press, in a debate which was largely unbiased and overwhelmingly positive, opening the door to greater success on German soil. One comment was that: 'in uniting a brutal, Nordic joy in colour, influences from Manet and a tendency towards reverie, something quite unique arises.' The critics pointed him out as an artist in colour, who was also consciously childlike, naive and primitive in his language of form. From previously having been seen as an artistic anarchist, he was now the epitome of a child of nature, uncontaminated by culture.

Anxiety, 1894
Angst
Oil on canvas
94 x 73 cm (37 in x 28 ⅜ in)
M 515

The background landscape, inside Kristiania Fjord is the same that we find in The Scream. The pale, ghostly faces come towards us like a procession of ghosts, in a line which could almost be seen as a funeral cortège. One of Munch's many literary texts sheds light on the painting:

'I saw all the people behind their masks – smiling, phlegmatic – calm faces – I saw through them and there was suffering – in them all – pale bodies – relentlessly hurrying – running around along a winding road – whose end was the grave – '

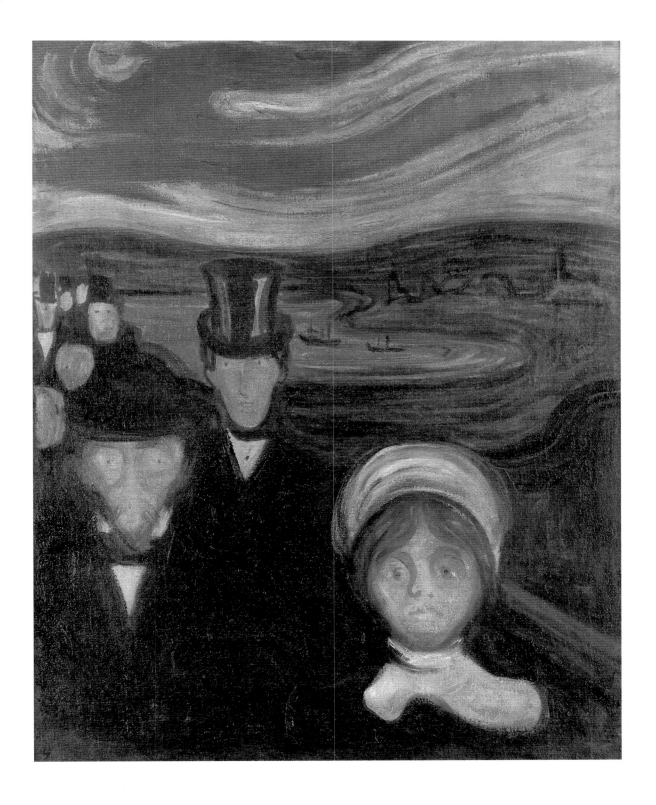

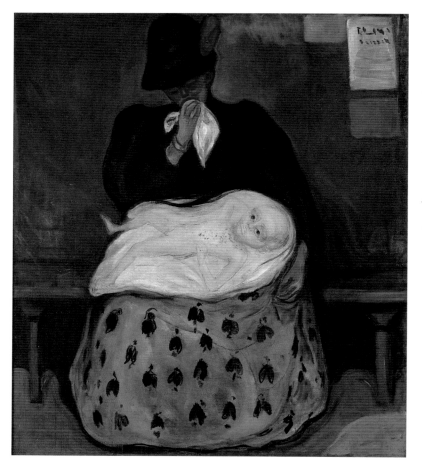

Inheritance, 1897-99
Arv
Oil on canvas
141 x 120 cm (55 ½ in x 47 ⅛ in)
M 11

The sick, greenish-pale child in its mother's arms lies in a position which has been seen in conjunction with the Madonna. The inevitable approach of death is symbolised by the falling autumn leaves on the mother's skirt. The fact that the title was intended to indicate inherited syphilis is supported in that Munch himself called the picture The Syphilitic Child.

Women in Hospital, 1897
Kvinner på hospitalet
Oil on canvas
110.5 x 101 cm (43 ½ in x 39 ¾ in)
M 28

It is likely that the motif stems from a visit to the famous mental hospital, La Salpétrière in Paris. One of the doctors there, psychiatrist Paul Contard, was a friend of Munch's. He was also painted by Munch together with a mutual friend, the German graphic artist Paul Herrmann.

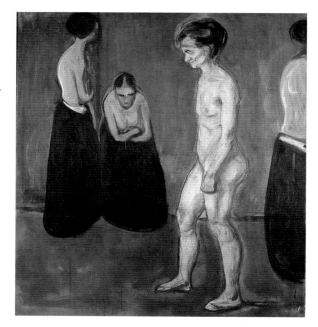

Red Virginia Creeper, 1898–1900
Rød villvin
Oil on canvas
119.5 x 121 cm (47 in x 47 ⅝ in)
M 503

The red virginia creeper, which gives the picture its title, appears not only to be organically but also biologically alive. It knots itself around the house almost in a stranglehold as if part of a macabre dance. The tree trunk with the naked branches to the left has associations with death. A tragedy appears to have taken place in the house, a tragedy the man in the foreground sees in his mind's eye.

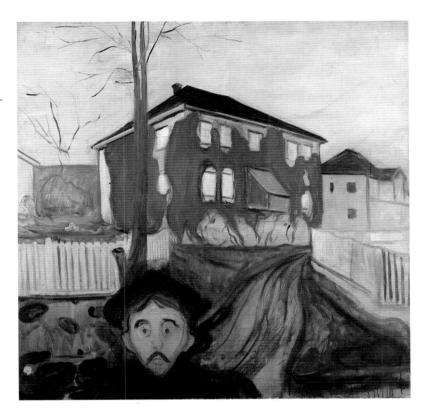

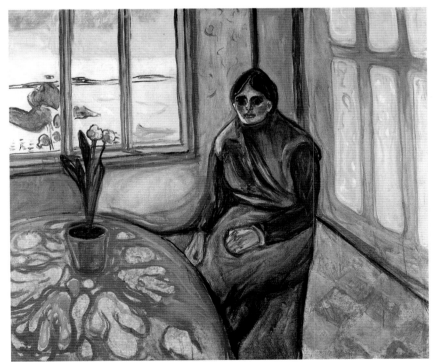

Melancholy/Laura, 1899
Melankoli/Laura
Oil on canvas
110 x 126 cm (43 ¼ in x 49 ½ in)
M 12

According to tradition, the staring, introspective woman was Munch's sister Laura, who suffered from melancholia (as manic depression was called at the time). Forced into the corner between the window and its reflection on the wall behind her, she appears completely isolated from reality. The cool, harmonious countryside outside contrasts with the clashing, blood-red tablecloth and the flower inside.

Metabolism, 1899
Stoffveksling
Oil on canvas
172.5 x 142 cm (67 ⅞ in x 55 ⅞ in)
M 419

The painting – a paraphrase of the Adam and Eve motif, was later painted over, but in its original design the roots of the tree extended into the frame, feeding from the dead. 'It is a picture of the strong, guiding forces of life,' as Munch put it. ●

Train Smoke, 1900
Togrøk
Oil on canvas
84.5 x 109 cm (33 ⅞ in x 42 ⅞ in)
M 1092

The picture is one of a series of landscapes from the turn of the century, with rhythmic and lyrical tones in surfaces, colours and lines, bearing hardly any traces of the earlier nervous energy and restless experimentation. The tentative observation of nature is portrayed in a classic, simplified technique in the synthesising art nouveau style of the time.

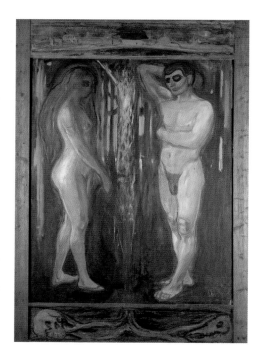

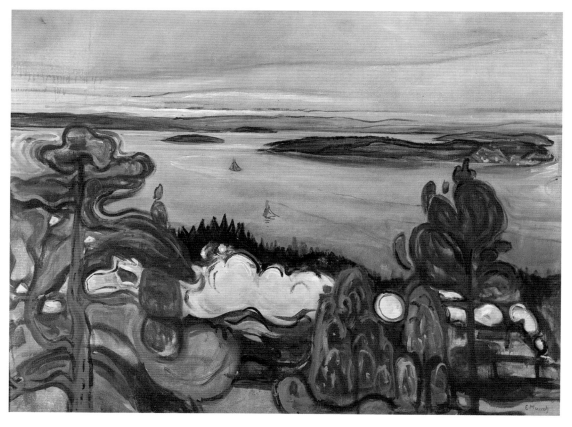

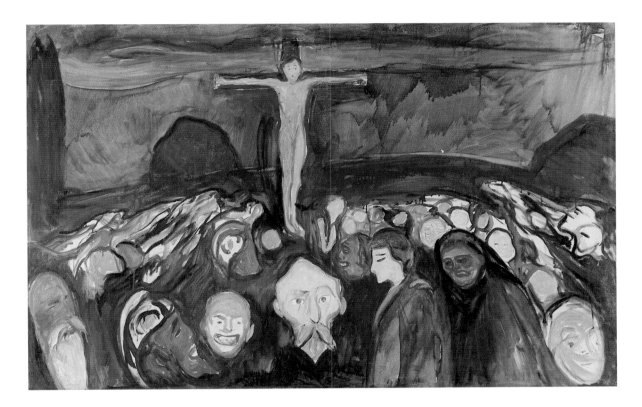

Golgotha, 1900
Golgata
Oil on canvas
80 x 120 cm (31 ⅛ in x 47 ⅛ in)
M 36

Both the crucified figure and the man in profile in the foreground bear the features of the artist. The crucified artist is the object of the crowd's homage and derision, but in the crowd he becomes part of the mass. The demonic female figure places a hand on his shoulder. The existential choice is either to create in suffering or resign oneself to the trivial life.

In his aim to portray 'the most subtle visions of the Soul', Munch establishes a set of constant images and symbols which he uses to suggest strong, often complicated, feelings. These symbols include the frequently used pillar of moonlight – a reflection of the moon on the sea. This phallic symbol immediately conveys erotic associations as well as a melancholy atmosphere. At the same time the sign plainly indicates the line of the horizon and catches the eye, so that it will not lose itself in the picture.

Another central feature is the shadow which can grow together with a person or a group of people to create an emotional unit. The shadow often adds something paralysing, heavy or threatening to the motif, for example as can be seen in the motifs *Puberty* and *Vampire*. The curving line of the shore also became a firm symbol in Munch's art. This constitutes the background to several of the love motifs in *The Frieze of Life* and suggests a lyrical and melancholy mood. The shoreline also creates space and forms a natural border between land and sea.

Several motifs show a woman dressed in white, a statuesque, shining figure, whose presence is purely symbolic in nature. The woman dressed in red, who we see in *Ashes*, for example, is the

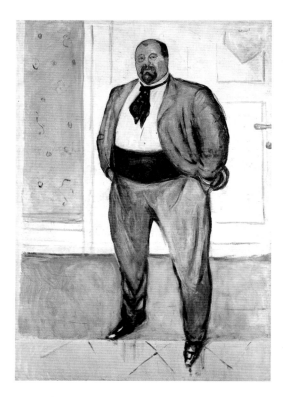

Consul Christen Sandberg, 1901
Konsul Christen Sandberg
Oil on canvas
215 x 147 cm (84 ⅜ in x 57 ¾ in)
M 3

To capture Christen Sandberg's vast physiognomy and warm personality, Munch has created a massive canvas, and now – for the first time since the 1880s – returns to the monumental full figure portrait. However, he introduces a new radical feature: the eye-catching unpainted sections of the background.

The Wood, 1903
Skog
Oil on canvas
82.5 x 81.5 cm (32 ⅜ in x 32 in)
M 301

Munch's many landscape motifs are always drawn from places close and well-known to the artist. Here we see a small part of the forest next to his house in Åsgårdstrand, a powerful, colourful painting, painted with eruptive strength in a short period of time.

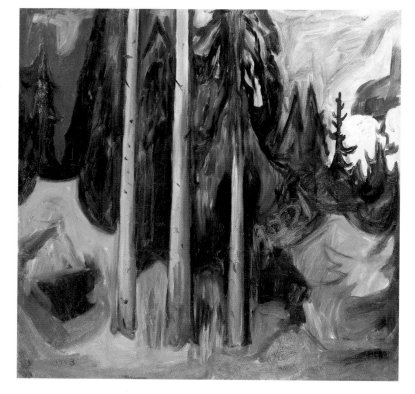

Self-portrait in Hell, 1903
Selvportrett i helvete
Oil on canvas
82 x 60 cm (32 ¼ in x 23 ½ in)
M 591

There is in existence a photographic self-portrait, taken in the summer of 1903, where Munch stands naked in approximately the same position as in the painting, with a pale body and sunburnt face against a verdant background. The marked lighting from below in the painting also has a parallel in this photograph, but the shrieking colours and the threatening shadow behind the model express a condensed atmosphere of angst which is the painting's alone.

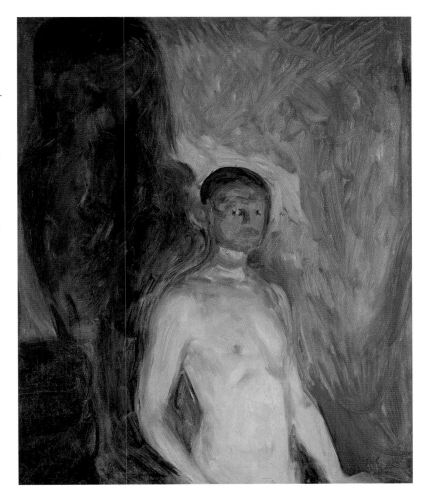

symbol of female sensuality while the woman in black becomes a symbol of resignation and bitterness. By placing these female types together as elements in different constellations, Munch also in this respect appears to be playing with his signs and symbols more by intuition than by design.

Colour in Munch's art is often clearly symbolic in nature, although it is impossible to talk about a simple formula for interpretation. However, colour, like the shoreline in Åsgårdstrand, appears to have a concrete basis in reality. A green face can symbolise a passive, suffering attitude in contrast to a red face, which characterises an active, choleric temperament. In _Death in the Sick Room_ (1893) we see, for example, that Munch depicts his father and his sister with red faces while the rest of the family are a green-ish pale colour. His father and his sister Laura were restless and hot-blooded in nature, while the other

Four Girls in Åsgårdstrand, 1903
Fire piker i Åsgårdstrand
Oil on canvas
87 x 111 cm (34 ¼ in x 43 ⅜ in)
M 488

*The child's mental world is one of many
themes in Munch's art around the turn of
the century and children from the coastal
village of Åsgårdstrand became an
important group motif. Here Munch has
placed four of the neighbours' children
facing forwards against the yellow wall of
his small house in Åsgårdstrand. The
children are portrayed with a child-like
trust in their expression, which also
indicates a decorative intention.*

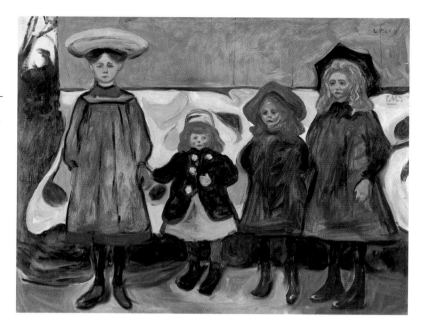

Two Girls with Blue Aprons, 1904–5
To piker med blå forklær
Oil on canvas
115 x 93 cm (45 ¼ in x 36 ½ in)
M 278

*Contemporary critics constantly compared Munch's
art with children's art, his figures with dressed
dolls, and described his painting technique as a
conscious imitation of children's painting. The
colour scheme of few clear tones: red, green, blue
and ochre – of which this painting is a prime
example – were seen by some as a 'Chaos of
poisonous Colours'.*

Bathing Men, 1904
Badende menn
Oil on canvas
194 x 290 cm (76 ⅜ in x 114 ⅛ in)
M 901

A major project from the summer of
1904 in Åsgårdstrand is this vital picture
of bathing men in monumental format. It
was the largest canvas Munch had ever
till then undertaken, a fact which appears
to indicate a conscious intention. It is
possible that he hoped it would find a
home in the collection of the Duke of
Weimar, the city where he was offered a
studio at the Art Academy.

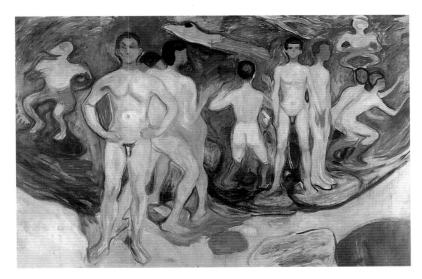

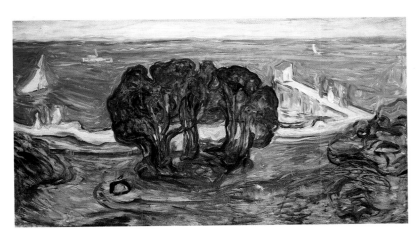

Youth on the Beach, 1904
Ungdom på stranden
Oil on canvas
90 x 174 cm (35 ⅜ in x 68 ½ in)
M 35

The painting with its thoughtful,
suggestive atmosphere is included in what
is known as the Linde Frieze, a series
which Munch's patron Max Linde in
Lübeck, ordered for the room of his four
sons, but which he declined when the
paintings proved too erotic for children.

Trees by the Beach, 1903–4
Trær ved stranden
Oil on canvas
93 x 167 cm (36 ½ in x 65 ⅜ in)
M 14

Like the above painting, this painting is
also part of the Linde Frieze. The
colouring of the landscape, with the
powerful group of trees in green swaying
in the wind against the strong blue,
windswept sea, is unusually strongly
portrayed, even for Munch.

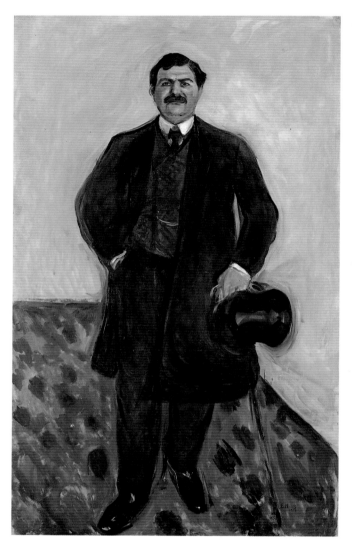

Herrmann Schlittgen/The German, 1904
Herman Schlittgen/Tyskeren
Oil on canvas
200 x 119.5 cm (78 ⅜ in x 47 in)
M 367

The German painter, graphic artist and caricaturist Hermann Schlittgen related how he was painted in the hotel 'Zum Elefanten' in Berlin. Schlittgen concludes with the words: 'The poor bedside rug, which lay under my feet, became in the painting a magnificent oriental carpet, the decay and yellowish touches in the room, Munch transformed into noble lemon yellow, my jacket to clear ultramarine.'

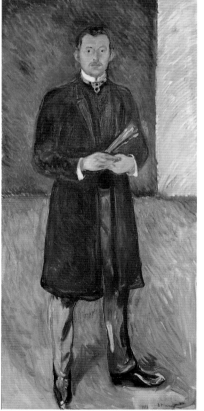

Self-Portrait with Brushes, 1904
Selvportrett med pensler
Oil on canvas
197 x 91.5 cm (77 ½ in x 36 in)
M 751

In Self-portrait with Brushes, Munch portrays himself in all his mature power as an artist. No longer is he the angst-ridden painter of The Sick Child of the 1880s, nor the inspired poet of love and death of the 1890s but an artist with full confidence in his abilities and his brushes.

From Thüringerwald, c. 1905
Fra Thüringerwald
Oil on canvas
80 x 100 cm (31 ⅜ in x 39 ¼ in)
M 688

In the decade around the turn of the century, Munch lived a hectic and itinerant life on the Continent. His bad nerves developed into chronic illness and his alcohol consumption increased considerably, something which again led to uncontrolled behaviour. In 1905–1906 he took refuge in Bad Kösen and Bad Ilmenau in Thüringia, where he painted a number of monumental landscapes.

Winter. Elgersburg, 1906
Vinter. Elgersburg
Oil on canvas
84 x 109 cm (33 in x 42 ⅞ in)
M 568

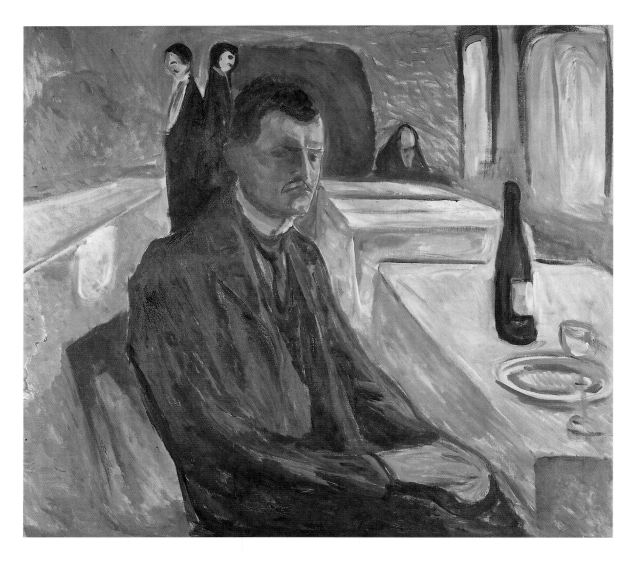

Self-portrait with a Bottle of Wine, 1906
Selvportrett ved vinflasken
Oil on canvas
110.5 x 120.5 cm (43 ½ in x 47 ⅜ in)
M 543

In Self-portrait with a Bottle of Wine Munch is equally melancholic and passive, as he appears self-confident in Self-portrait with Brushes. The entire position, the relaxed hands and the resigned expression, indicate that all power has deserted him. The atmosphere presses down on the artist, conveying an oppressive feeling of melancholy and loneliness.

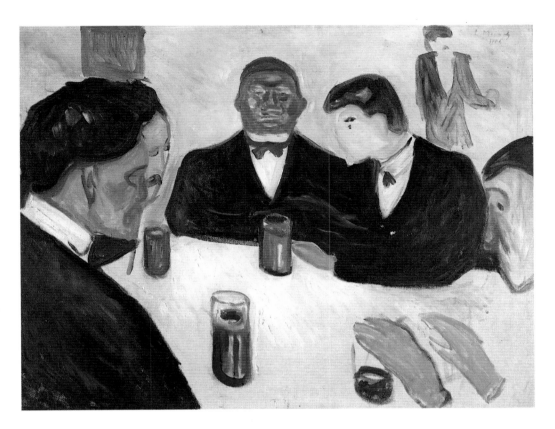

Drinking Bout, 1906
Rundt bordet
Oil on canvas
76 x 96 cm (29 ⅞ in x 37 ¾ in)
M 181

At the Salon des Indépendants in 1906, Drinking Bout was received with indignation as the painting was seen as being highly unfinished. Although different in many way, the expressive working of the surface has formal features in common with the decorative style being developed by Matisse.

members of the family tended to be melancholic in temperament. In the love motifs the woman is often depicted as filled with blood and in a superior position, while the man tends to be pale and passive.

A composition which Munch often uses to reproduce tension in the human mind is the figure facing front in the foreground with an event taking place in the background, which can be interpreted as the mental picture of that figure – what he or she sees in his or her inner eye.

From 1902 until his breakdown in 1908 Munch was almost permanently resident in Germany, where he completed a number of monumental full-length portraits which were greeted with general respect. These included the portraits of Walther Rathenau, Hermann Schlittgen (*The German*) and Marcel Archinard (*The Frenchman*). The models are depicted with deep psychological insight and concentrated strength without the banal hero-worship traditionally associated with this genre. Munch also painted a number of portraits of children and the portrait of the four sons of Max Linde, his patron in Lübeck, has been classed as the finest children's portraits of the 20th century.

During this period Munch often exhibited in Germany, Vienna

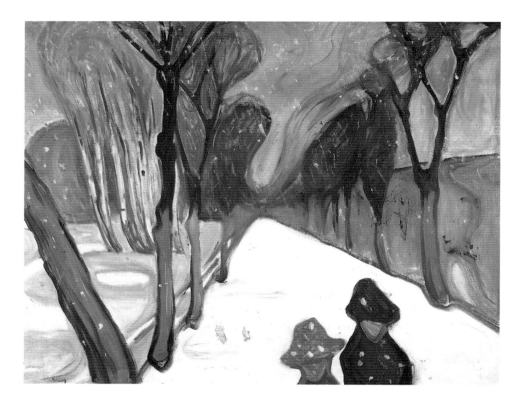

and Paris. Undoubtedly the work he produced during the 16 years between 1892 and 1908 came to be crucial to the development of the Expressionist movement in art, primarily in Germany but also partly in France. In these years Munch came to take on a more extrovert attitude to life than previously, as indicated by the monumental *Bathing Men* (1907, Ateneum, Helsinki). The painting was painted in the summer of 1907 when Munch settled down in Warnemünde on the Baltic and experimented in a number of different techniques. This life-affirming work is built up with the help of a system of angled strokes. The strictly formulated contrast between the horizontal lines of the sea and the beach and the statuesque vertical shapes of the advancing men contributes to the powerful monumental nature of the picture.

At the same time he painted a number of more realistic, genre-focused motifs, some spontaneously carried out using impasto techniques, like Matisse in his earliest Fauvist works. However, unlike the decorative refinement which was to become a fundamental element in Matisse's art, Munch builds further on his expressionistic base. Often the oil paint is squeezed out in thick layers directly from the tube on to the canvas, as, for example, in *Old Man in Warnemünde* (1907).

The Avenue in Snow, 1906
Snevær i alleen
Oil on canvas
80 x 100 cm (31 ⅜ in x 39 ¼ in)
M 288

Both the treatment of colour - the clear colours in the free-standing surfaces - and the structure of the painting call to mind paintings of the Fauves. That same year Munch had exhibited in the same room in the Salon des Indépendants as several of the Fauves, something which has been seen as an indication that the group owed a debt to Munch's art to a certain extent.

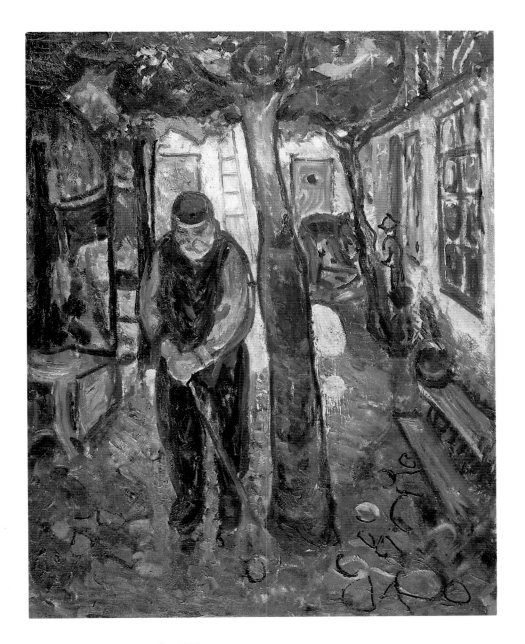

Old Man in Warnemünde, 1907
Gammel mann i Warnemünde
Oil on canvas
110 x 85 cm (43 ¼ in x 33 ⅜ in)
M 491

In the summer of 1907 Munch settled down in Warnemünde on the Baltic, where he experimented in a number of different directions, including a spontaneous technique using thick coats of colour. Often he presses the oil paint in thick layers straight from the tube onto the canvas, as can be seen in Old Man in Warnemünde.

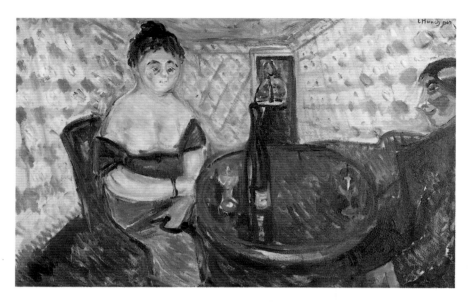

'Zum süssen Mädel', 1907
Oil on canvas
85 x 131 cm (33 ⅜ in x 51 ½ in)
M 551

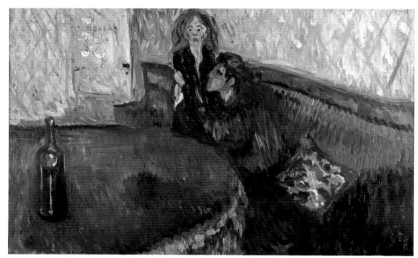

Desire, 1907
Begjær
Oil on canvas
85 x 130 cm (33 ⅜ in x 51 ⅛ in)
M 552

A series of strong negatively loaded motifs, which Munch jointly entitled The Green Room, can be seen as a new and bitter expression of the love motifs in The Frieze of Life, where, among other things the elegiac shoreline in Åsgårdstrand is replaced by the interior of a bordello. The action takes place in a small box-like room with green wallpaper. The fact that the motif is seen at close hand expands the claustrophobic room, as if it were photographed with a wide-angle lens. Loneliness and alienation is depicted more desperately and aggressively than ever before and appears to be the common basic emotion for the group of pictures.

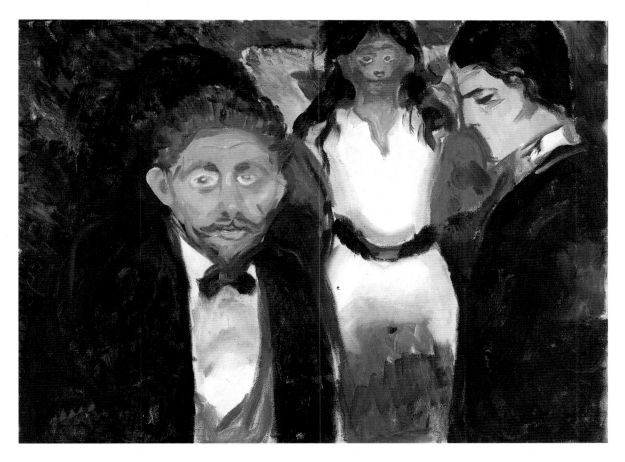

Jealousy II, 1907
Sjalusi II
Oil on canvas
76 x 98 cm (29 ⅞ in x 38 ½ in)
M 447

He also uses this technique in a series of highly negatively charged motifs to which he gives the joint title *The Green Room;* a new and bitter version of the love motifs from the original *Frieze of Life*, where among other things the elegiac shoreline from Åsgårdstrand is replaced by the interior of a bordello. In many of the motifs the action takes place in the same room, a small box-like stage with glaring green-checked walls with no windows, and only one door on the right in the rear wall leading out of the room. In two of the motifs, *Zum süssen Mädel* and *Desire*, we see how consciously Munch uses the round table as an aggressive means of creating space. The fact that the motif is seen at close hand means that the suffocating room is considerably expanded, as if it had been photographed using a wide-angle lens. The contrast between red and green and the fragmented line technique suggests a nervous unease. The sense of strangeness and loneliness is conveyed in a more desperate and aggressive way than ever before and appears to be the common fundamental atmosphere throughout the series.

In this unique technique, the motif *The Death of Marat II* takes on its final form in one of the most exciting works from the period. The motif goes back to the traumatic break between Munch and his fiancée Tulla Larsen in 1902 when Munch inadvertently shot himself in the finger. The artist's alter ego lies naked on the bed, parallel with the plane of the picture and with a bloody hand hanging down, while the woman stands facing directly forward with her arms straight down by her sides. The picture is built up through a balanced interplay of horizontals and verticals when it comes to the figures, the room and even the brush strokes. The only break is the diagonal created by the man's arm. Within this highly architectural structure is placed a strong, emotionally loaded, erotic scene, which, with the help of what was at the time an almost unthinkably primitive method of painting, depicts the artist's aggressive attitude to his motif.

Munch also spent the following summer in Warnemünde. Two of the most interesting works from that summer are *Mason and Mechanic* (also called *Baker and Smith* and *Mason and Butcher*, which indicates that

The Death of Marat I, 1907
Marats død I
Oil on canvas
150 x 200 cm (59 in x 78 ⅜ in)
M 351

The point of departure for this motif is the break-up of the relationship between Munch and his fiancée Tulla Larsen in 1902 when Munch inadvertently shot himself in the finger. The event developed into a trauma which was to haunt Munch for many years and which he examined in painting in a number of versions, one of which he gave the title The Murderess.

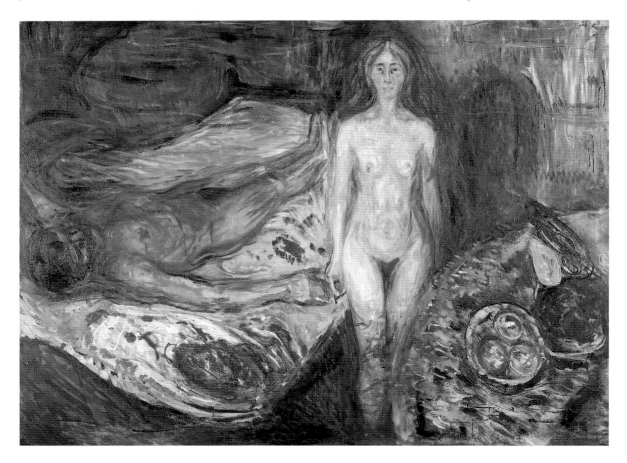

Man and Woman on the Beach, 1907
Mann og kvinne på stranden
Oil on canvas
81 x 121 cm (31 ⅞ in x 47 ⅝ in)
M 442

This motif is also linked to the break-up of the relationship between Edvard Munch and Tulla Larsen. In his many notes, Munch refers to Tulla Larsen's lavish hats which can be identified here. What is being described is the death of love – the impossibility to regain earlier contact.

The Death of Marat II, 1907
Marats død II
Oil on canvas
152 x 149 cm (59 ¾ in x 58 ⅝ in)
M 4

In Warnemünde in 1907 Munch developed a distinctive line technique. With a set of strong vertical and horizontal brush strokes, the canvas takes on a distinctive vitality. The spontaneous, primitive method of painting also indicates the artist's personal aggression towards the motif. Regarding this technique, Munch himself said: 'the surface was broken and a certain Pre-Cubism expressed itself...'

Cupid and Psyche, 1907
Amor og Psyke
Oil on canvas
119.5 x 99 cm (47 in x 38 ⅝ in)
M 48

In Cupid and Psyche Munch uses the same line technique as in The Death of Marat II. Compared with The Death of Marat II, however, Cupid and Psyche is more lyrical, with a sense of reconciliation.

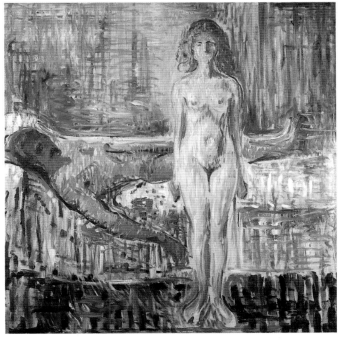

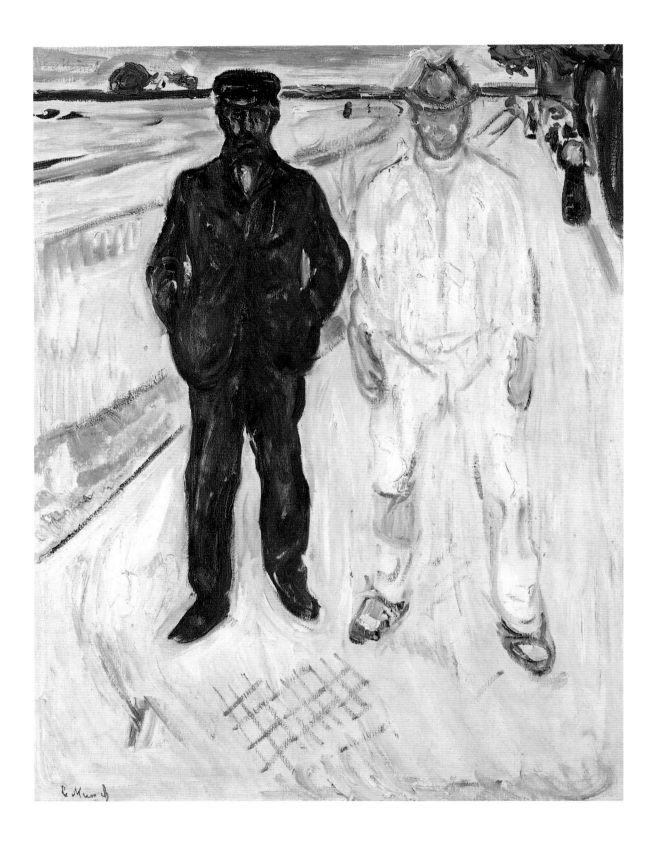

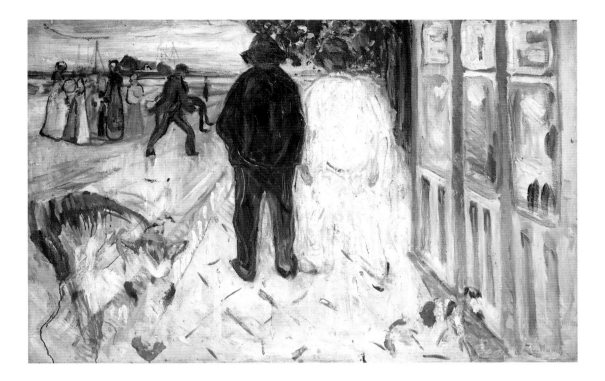

The Drowned Boy, 1908
Den druknede gutt
Oil on canvas
85 x 130 cm (33 ⅜ in x 51 ⅛ in)
M 559

Mason and Mechanic, 1908
Murer og mekaniker
Oil on canvas
90 x 69.5 cm (35 ⅜ in x 27 ¼ in)
M 574

Both in The Drowned Boy and Mason and Mechanic (which has also been called Baker and Smith and Mason and Butcher) where a light and dark male figure walk side by side, one receives the strong impression that the two figures represent two aspects of the same person. Seen in this way they represent the light and dark powers battling for control of the artist. Munch himself referred to such powers by talking about 'the Schism of the Soul as if two Birds were kept together which each pull in their own direction – a terrible battle in the Cage of the Soul.'

the title is not of prime importance) and *The Drowned Boy*. Both motifs use the same scene, the beach promenade outside Munch's house at Am Strom in Wärnemunde, and in both pictures we see a light and a dark male figure walking side by side, one heading out towards the observer and the other inwards into the picture. The experience of a split personality had occupied Munch for several years but here the feeling of 'walking beside oneself' is intensified. Soon afterwards Munch was to summarise the battle between the light and dark forces in his mind with the words:

The influence of alcohol brought the Schism of the Mind or the Soul to its extreme – until the two States like two Birds in a single cage each pulled in their own direction and threatened to Break down or Tear apart the Chain – Under the violent schism of these two Mental states arose an increasingly stronger inner tension – a Conflict – a fearful Battle in the cage of the Soul.

After years of restless life, nervous illness and alcohol abuse, breakdown came in the autumn of 1908 and Munch spent the following eight months in Dr. Jacobson's nerve clinic in Copenhagen. When he returned to Norway he first settled in Kragerø and here began a completely new chapter in his life and in his art.

Dr. Daniel Jacobson 1908
Oil on canvas
204 x 111.5 cm (80 ¼ in x 43 ⅞ in)
M 359A

*After many years of restless life on the Continent,
characterised by poor nerves and alcohol problems, in
autumn 1908 Munch was admitted to Dr. Jacobson's
fashionable nerve clinic in Copenhagen. After a short
while Munch transformed his sickroom into a studio,
where his paintings included this dynamic portrait of his
doctor, depicting a very self-confident man standing with
his legs apart and his hands on his hips.*

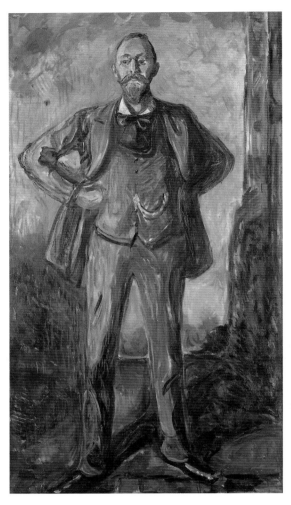

Jappe Nilssen, 1908
Oil on canvas
193 x 94.5 cm (75 ⅞ in x 37 ⅛ in)
M 8

*Jappe Nilssen was a close friend of Munch throughout his life.
This portrait of him – a violet figure against a green background
– is seen as a major work in the series of life-sized portraits
which Munch referred to as ' the bodyguard of my art'.*

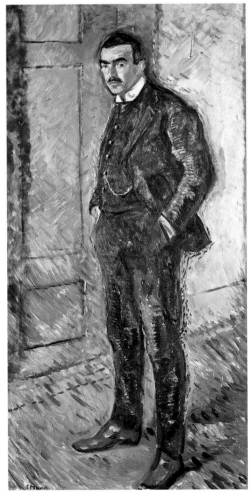

Adam and Eve, 1909
Adam og Eva
Oil on canvas
130.5 x 202 cm (51 ⅜ in x 79 ½ in)
M 391

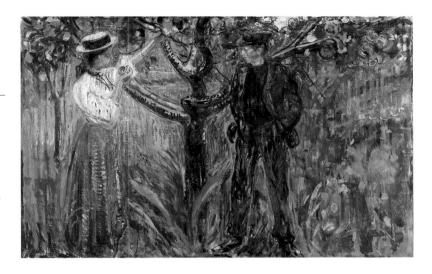

The Adam and Eve motif goes back a long way in Munch's art. Although this rendition of the motif may appear more authentic than the version of the 1890s, the underlying symbolism is clear. Eve stands with one arm outstretched towards the man while she eats the apple from her other hand. Adam is passive, almost hesitant, observing the 'temptress'.

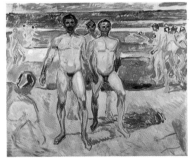

Bathing Men, 1911
Badende menn
Oil on canvas
203 x 230 cm (79 ⅞ in x 90 ½ in)
M 706

In 1907 in Warnemünde Munch set up a large canvas on the nudist beach, where he painted a powerful and monumental work of a group of naked men. After the picture was sold to the Finnish National Gallery, Ateneum, in 1911, Munch painted this replica, which preserves the formal elements in a somewhat more sketch-like execution.

Spring Work in the Skerries, 1910
Vårarbeid i skjærgården
Oil on canvas
92 x 116 cm (36 ⅛ in x 45 ⅝ in)
M 411

After his stay at Dr. Jacobson's clinic, Munch settled down in Kragerø in the Norwegian archipelago. It is as though Munch is growing into these natural surroundings and gaining new artistic strength. The rugged landscape and the people who work there come together in a pictorial whole.

Immediately he began to work for a competition to decorate the Aula (the Hall) of the University of Oslo. Despite considerable opposition to his entry, he finally won the competition and the decorations were completed in 1916. The central fields in this, his main work in Norwegian monumental painting – *History, the Sun*

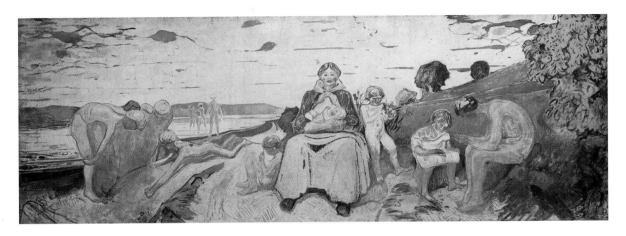

The Sun. Study for the Aula Decorations, 1910–11
Solen. Studie til Auladekorasjonene
Oil on canvas
450 x 777 cm (177 ⅛ in x 305 ⅞ in)
M 963

The Munch Museum holds much of the preparatory work for The Sun in the Aula of Oslo University. The life-giving and powerful aspects of the sun are recreated in Munch's own work with brush and paint. The eye of the observer is drawn towards the sun as if through a shaft of light, while the spectrum of colours emanating from the sun splash outwards. The sun becomes the emblem of Munch's new nature worship after recovering from his breakdown in 1908.

The Researchers/Alma Mater, 1909–16
Study for the Aula Decorations
Forskerne/Alma Mater
Studie til Auladekorasjonene
Oil on canvas
480 x 1100 cm (188 ⅞ in x 433 in)
M 1091

The numerous designs and studies for Alma Mater in the Aula of Oslo University in the collection of the Munch Museum, indicate that Munch was seeking a vision which constantly escaped him. In the final version, the 'researching' children were reduced to three, to the right, the artist added an upright group of trees and reinforced the shoreline and the fjord to the left.

The Murderer, 1910
Morderen
Oil on canvas
94.5 x 154 cm (37 ⅛ in x 60 ⅝ in)
M 793

Typical of Munch is the way an everyday scene is transformed into a dramatic motif. The light rocks on the right contrast with the dark mountainside on the left-hand side of the painting and emphasise the demonic expression of the man coming towards us with a violently green face which contrasts with the blood dripping from his hands.

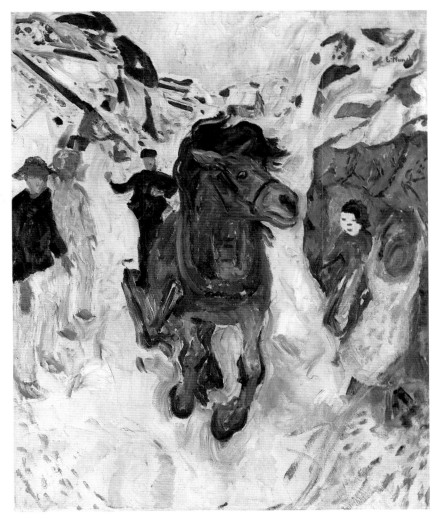

Galloping Horse, 1910–12
Galopperende hest
Oil on canvas
148 x 119.5 cm (58 ¼ in x 47 in)
M 541

The combination of refined and powerful brush strokes suggests the wild speed of the horse. With its head turned to the right, it comes towards us through the snow, sweeping the small children aside. The illusion of movement is obtained using exaggerated foreshortening.

and *Alma Mater* – clearly show the new trends in his art and at the same time bear witness to the importance of his encounter with the nature of Norway, which resulted in a new feeling for harmony, classic simplicity in composition and bold, vital brushstrokes.

In parallel with the Aula entries, Munch developed a type of landscape painting of a monumental nature, including a series of winter motifs from Kragerø. These include *Winter in Kragerø* (1912) where the majestic fir gathers together and condenses the monumental landscape. It is solid and cubist, almost Cézanne-like in design. In these winter landscapes Munch used the pure white colour in an unusually bold way.

In *The Yellow Log* (1912) we see an example of how Munch varied the use of the exaggerated perspective for new purposes. If we follow the stripped log into the picture, our glance is swiftly drawn in and caught

Winter in Kragerø, 1912
Vinter i Kragerø
Oil on canvas
131.5 x 131 cm (51 ¾ in x 51 ½ in)
M 392

Winter in Kragerø is a magnificent, monumental work. The painting with the proud, strong fir tree is solid and Cubist, almost Cézanne-like in structure. Previously, Munch had called his works of art his 'children'. The landscape paintings he now calls his 'children with nature'.

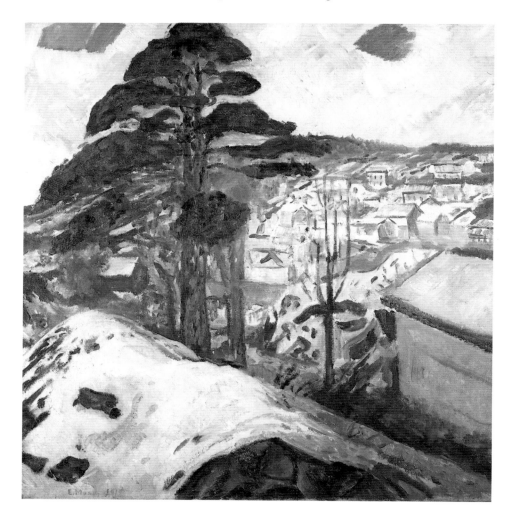

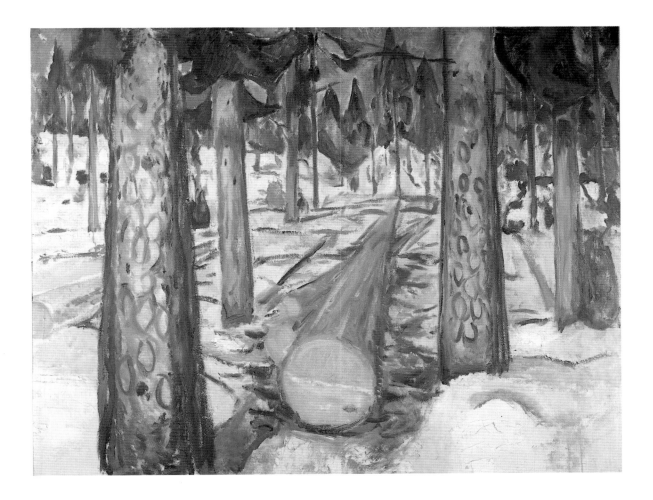

The Yellow Log, 1911–12
Den gule tømmerstokken
Oil on canvas
131 x 160 cm (51 ½ in x 62 ⅞ in)
M 393

The forest interior with strong, upright trunks of fir trees was a motif which particularly occupied Munch at this time. Using an exaggerated perspective, created by the yellow log, stripped of bark, in the centre, a dynamic is formulated which reproduces itself into the very forest.

by a tree in the background. Munch's use of static and dynamic effect in this period has analogies not only with Italian Futurism and its focus on explosive movement, but also with the kinetic effects of film.

The obvious way in which Munch transferred the image of nature to canvas created a 'Munch complex' in young contemporary Norwegian painters. Nobody managed as he did to create a picture of nature as natural as nature itself, with fast but secure brush strokes and using a minimum of means. In this period too we also see a number of portraits, bathing studies, nudes and landscapes. Previously he had referred to his paintings as 'my children', now he talked about his landscapes as 'my children with nature'.

The landscapes after 1916 are often composed using an intricate play of convex and concave shape fragments. The young Franz Marc, himself originally an admirer of Munch's art, has clearly inspired Munch to adopt such means to portray man at one with nature. Such

a structure can be found in *Bathing Man* (1918). Also several of Munch's animal motifs such as *Spring Ploughing* (1916) draw on Franz Marc's depiction of animals integrated into their surroundings.

At the famous Sonderbund exhibition in Cologne in 1912 the intention of which was to provide an overview of the most important trends in modern art, Munch was given his own room. Implicitly he was being presented as the living artist of the greatest importance to the shape of modern art. The next year at the Autumn Exhibition in Berlin, Munch and Picasso, as the only foreigners invited, were each given their own room. But while further developments in modern art were characterised by the free structuring of fragments of reality, as we see in Cubism and Futurism, external reality remained a fundamental element in Munch's art.

Between 1912 and 1915 Munch took up a new subject, the relationship between his alter ego – the ageing artist – and his young model. It is the relationship between man and woman from *The Frieze of Life* in a new variant. *In Man and Woman I and II* (1912/15) the scene is his little house in Åsgårdstrand. The diagonal beams in the

Bathing Man, 1918
Badende mann
Oil on canvas
137.5 x 199 cm (54 ⅛ in x 78 ¼ in)
M 364

In Bathing Man we see how the shimmering blue light reflects the man's prominent muscles which again are reflected in the shapes of the waves and the beach. The painting is a prime example of Munch's desire to integrate living individuals and nature.

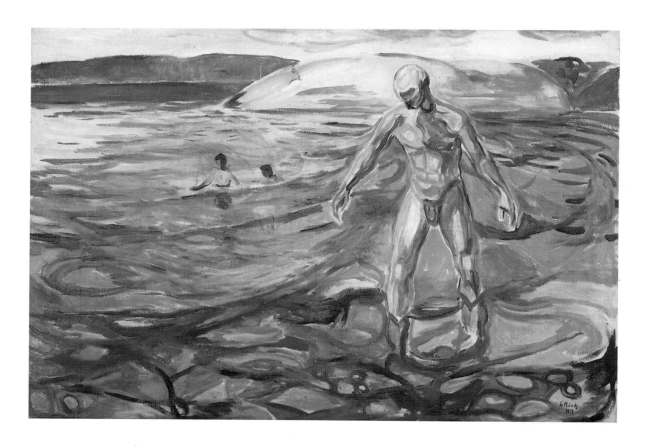

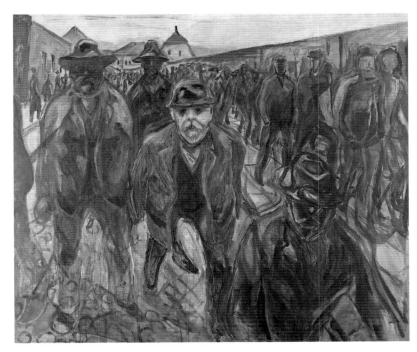

Workers on their Way Home, 1913–15
Arbeidere på hjemvei
Oil on canvas
201 x 227 cm (79 ⅛ in x 89 ¼ in)
M 365

The workers come towards the observer in a rapid stream, a gathering of serious, fierce, almost demonic faces which cannot be stemmed. An unstoppable mass moving into a new time. But the picture is also a study in movement which parallels that of cinematography.

Spring Ploughing, 1916
Vårpløying
Oil on canvas
84 x 109 cm (33 in x 42 ⅞ in)
M 330

In 1916 Munch purchased the property Ekely just outside Oslo, surrounded by farmland. Here he was inspired by man's work with the earth. Spring Ploughing – strict, almost classical in structure in a play of upright forms – has as its strongest precursor Franz Marc's pictorial depiction of animals melting into their surroundings.

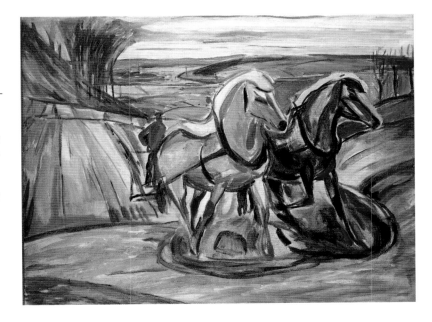

Haymaker, c. 1916
Slåttekar
Oil on canvas
130 x 150 cm (51 ⅛ in x 59 in)
M 387

Haymaker is an example of Munch's many motifs in which people and their surroundings influence each other and become equal parts of a larger whole. The man's movements with the scythe are repeated in the curves of the land and the circular forms of the sky and the trees. The painting is the image of movement itself.

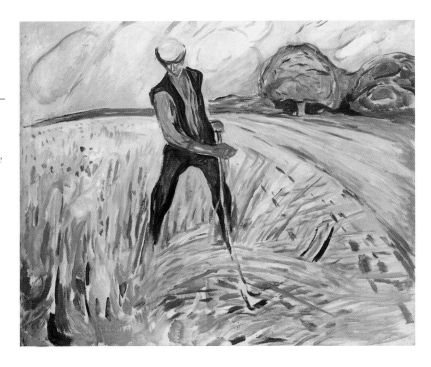

Man and Woman II, 1912-15
Mann og kvinne II
Oil on canvas
89 x 115.5 cm (35 in x 45 ⅜ in)
M 760

In a series of expressive paintings, Munch places himself and his model in the room of his small house in Åsgårdstrand. The beams in the ceiling form diagonal, aggressive lines, creating space. Based on a personal situation, Munch manages to convey something universal about the relationship between man and woman. This is the theme of The Frieze of Life in a new guise.

ceiling creating space in *Man and Woman II* are strongly accentuated and form aggressive lines. A further element of unease is created in that the male figure in the foreground is deliberately blurred and massive in contrast to the clearly drawn female figure. In *Man and Woman I* a new formal element is introduced, which Munch was to

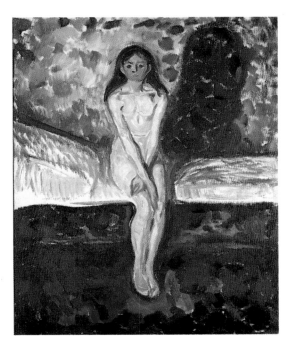

Puberty, c. 1914
Pubertet
Oil on canvas
97 x 77 cm (38 ⅛ in x 30 ¼ in)
M 450

In 1914, Munch again took up the motif of puberty from the 1890s, but this time in an entirely new expressive, almost aggressive language. The frozen, introverted anxiousness of the previous versions is here expressed in an eruption of brush strokes.

Death Struggle, 1915
Dødskamp
Oil on canvas
174 x 230 cm (68 ½ in x 90 ½ in)
M 2

The motif harks back to Munch's sister Sophie's death with her family gathered by the bed. In the very first sketches of the motif from the 1890s the sufferer's feverish fantasies are projected on the wall as hallucinatory faces. In this later version the disturbing wallpaper recalls these faces.

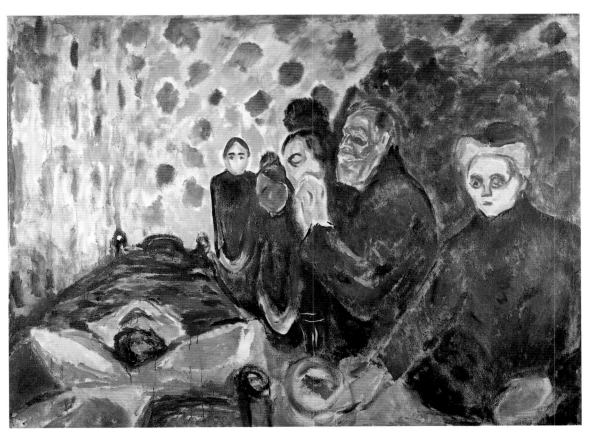

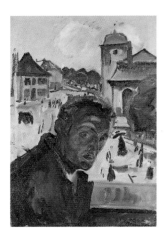

Self-Portrait in Bergen, 1916
Selvportrett i Bergen
Oil on canvas
89.5 x 60 cm (35 ⅛ in x 23 ½ in)
M 263

Throughout his life Munch created a long series of self-portraits, which constitute some of his most important works. The face of the artist which turns towards the observer with the intense staring eye in the centre of the picture expresses human despair which stands in contrast to the spring landscape outside with the church and the green trees.

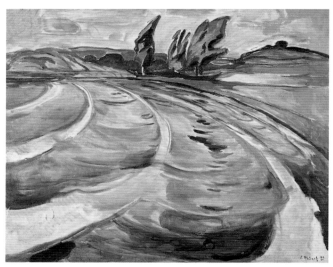

The Wave, 1921
Bølgen
Oil on canvas
100 x 120 cm (39 ¼ in x 47 ⅛ in)
M 558

In 1910 Munch bought the manor Nedre Ramme in Hvitsten on the west side of the Christiania Fjord, where he discovered new motifs including the animals of the farm and bathers on the rocks. However, he also painted the sea which breaks against the beach in long waves in the small bay below the house. The way in which he creates a monumental work with a motif whose dimensions are fairly modest and intimate in geographical terms is typical of Munch.

The Murderer in the Avenue, 1919
Morderen i alleen
Oil on canvas
110 x 138 cm (43 ¼ in x 54 ¼ in)
M 268

Early on, Munch used death as an underlying motif in many of his works. The Murderer in the Avenue, however, reflects death differently, in a more expressionist and vital style. With a few bold strokes he paints a face in a road already painted. We see the road through the murderer and the victim lies as an almost unnoticed shadow in the avenue.

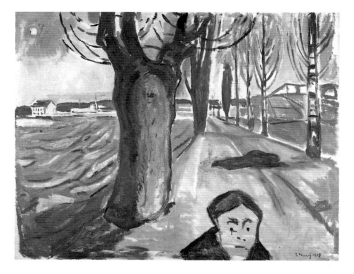

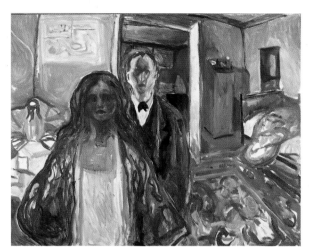

**The Artist and His Model/The Bedroom I,
1919–21**
Kunstneren og hans modell/Soveværelset I
Oil on canvas
134 x 159 cm (52 ¾ in x 62 ½ in)
M 75

_The picture is one of a series of pictures painted in Munch's
bedroom at Ekely. The artist and his model stand turned towards
us; she with her hair loose, in a night-dress and dressing gown, he
formally dressed in suit and tie. The unmade bed indicates an
intimate relationship. It is the self-scrutiny in the picture which
gives an unvarnished picture of an older man's relationship with a
younger woman._

**Model by the Wicker Chair,
1919–21**
Modell ved kurvstolen
Oil on canvas
122.5 x 100 cm (48 in x 39 ¼ in)
M 499

_Here the female model poses naked in
front of the wicker chair with her head
bent and arms dangling. The vigorous
colouring makes the picture a rare gem
from this period. The room, which
opens into new rooms in the
background is a new feature in
Munch's composition, which stands in
strong contrast to his many previous
closed, bare rooms._

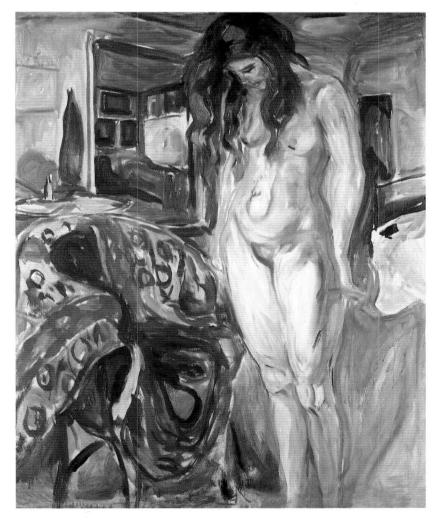

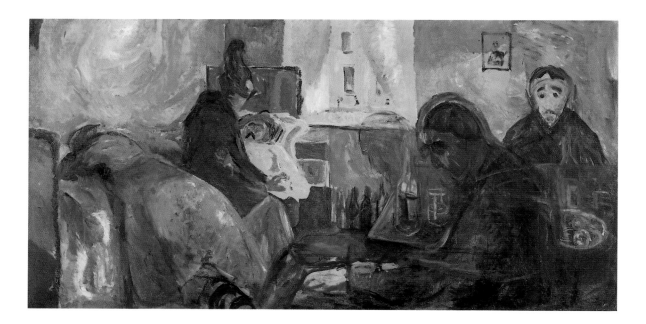

develop in the following years. This is the sudden appearance of space through an open door in the background where the room behind is often more strongly lit than the main room.

In 1916 Munch settled down at the property of Ekely, with its fields, fruit trees, berry bushes and coppices just outside Oslo. To the west ridges of Vestre Aker could be seen against the skyline while to the east the light over Oslo shone in the dark winter nights and to the south the view opened out to Oslo Fjord. Here he was to find motifs for a large number of landscape paintings in the years to come. While contemporary development in modern painting is characterised by the free depiction of fragments of reality painted without direct reference to an external world, the depiction of reality, constantly following times of day and seasons of the year, are vital elements in Munch's art. These pictures are characterised by strong, intense colours and explosive brush strokes.

At Ekely Munch had a number of large outdoor studios built where he worked for years on various monumental projects, primarily the series which has been termed *The Late Frieze of Life* and *The Human Mountain* or *Towards the Light*. It is likely that the main motivation for this work was probably a burning desire to produce a large, public, monumental work other than the University Aula. With the exception of a frieze for the Freia chocolate factory, Munch was never commissioned to produce such a work. Eye disease in 1930 was to put a definite stop to these ambitions.

The Death of the Bohemian, 1917-18
Bohemens død
Oil on canvas
110 x 245 cm (43 ¼ in x 96 ⅜ in)
M 377

The motif depicts the deathbed of Hans Jæger – Munch's friend and the central figure in bohemian circles in Kristiania in the 1880s. Munch himself was not present but bases the painting on the description of a close friend. The picture conveys a feverish anxiety and an experience of death with no illusions in full daylight with a window open towards life outside.

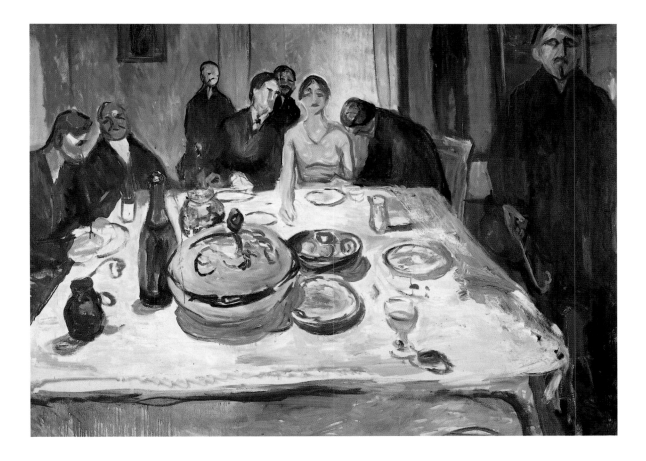

The Bohemian's Wedding, 1925
Bohemens bryllup
Oil on canvas
138 x 181 cm (54 ¼ in x 71 ¼ in)
M 6

The Bohemian's Wedding is dominated
by the almost Cézanne-inspired still life
of the table top, enormous in terms of
perspective. It presses the people inwards
within the painting and contributes to an
atmosphere related to Surrealism. The
bride sits as a light, straight figure
surrounded by dark-clothed, adoring men,
almost like a female Christ figure with
her disciples at the Last Supper.

During his years at Ekely, Munch also painted a long series of
portraits, both of close friends and public figures. He had several
models, his favourite being Birgit Prestøe, who can also be seen in
one of the main works from this period, *The Bohemian's Wedding*. To
judge from the many sketches and versions of this motif, Munch was
strongly preoccupied by this subject. Eight years earlier he had
painted *The Death of the Bohemian* whose rich painting and rhythmic
movement makes it a key work in Munch's later oeuvre. Munch also
indicated that he intended to paint a trilogy of bohemian motifs, but
the third was never realised.

On the initiative of Munch an exhibition of young German art
was arranged in Oslo in 1932. Here Munch was able to see a
colourful, almost vulgar painting which was clearly fascinating. The
latest work of Schmidt-Rotluff in particular appears to have struck a
chord with Munch as, for example, is seen in his latest version of
Jealousy (1933/35) where the colours sparkle and the brightness of the
light is unusually exaggerated. He also uses these new experiences in

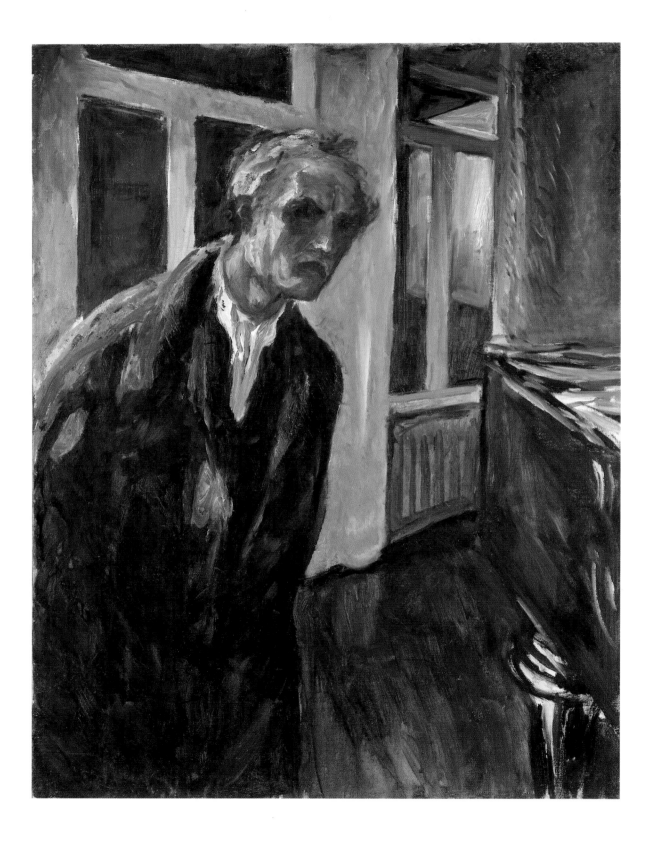

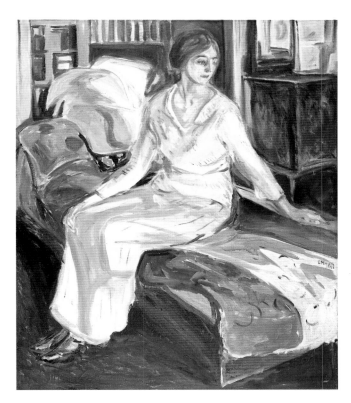

Sitting Model on a Couch, 1924
Sittende modell på divanen
Oil on canvas
136.5 x 115.5 cm (53 ⅜ in x 45 ⅜ in)
M 429

Edvard Munch's favourite model in the 1920s, Birgit Prestøe, appears with her distinctive beauty and coolness to have inspired Munch to a new creative period. Besides his clear painter-like qualities and his interesting perspective of space, this portrait shows that Munch has felt free - almost in the spirit of Cubism - to broaden the figure out across the surface.

Lucien Dedichen and Jappe Nilssen, 1925–26
Lucien Dedichen og Jappe Nilssen
Oil on canvas
159.5 x 134.5 cm (62 ¾ in x 52 ⅞ in)
M 370

Both Lucien Dedichen and Jappe Nilssen were friends of Munch's from early years. Dedichen was a doctor with a wide practice which also included Munch. In this portrait of the doctor and his patient, who is marked by death, Munch combines the new stylistic features and compositional logic which characterises his matter-of-fact 1920s art.

Self-portrait. The Night Wanderer, 1923–24
Selvportrett. Nattevandreren
Oil on canvas
89.5 x 67.5 cm (35 ⅛ in x 26 ½ in)
M 589

In this self-portrait Munch reveals sides of his life which most other people wish to keep hidden: anxiety and restlessness as a result of loneliness. The uncurtained windows and the bare room emphasise the feeling of loneliness and isolation.

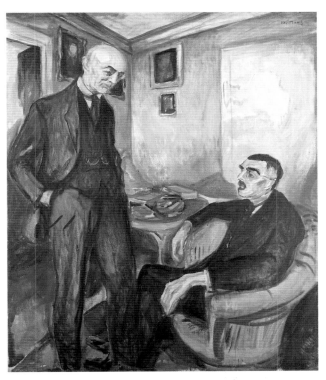

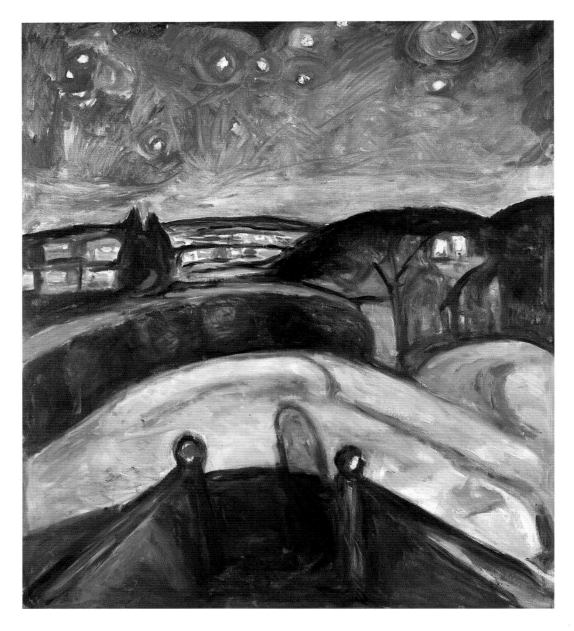

Starry Night, 1923-24
Stjernenatt
Oil on canvas
139 x 119 cm (54 ⅜ in x 46 ¾ in)
M 9

In the group of starry night motifs seen from Munch's veranda at Ekely, where the blue winter night conveys a fateful sense of melancholy, we see how Munch makes use of rounded shapes in constructing the painting. The shadow in the foreground – in all likelihood Munch's own shadow – expresses loneliness in the face of death.

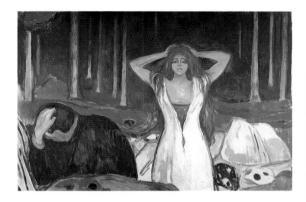

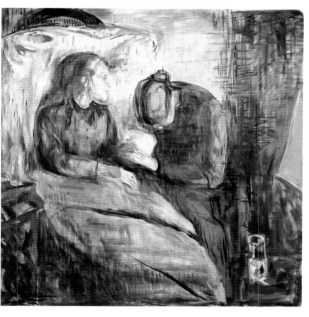

Ashes, 1925-29
Aske
Oil on canvas
139.5 x 200 cm (54 ⅞ in x 78 ⅜ in)
M 417

This a replica of the main motif of 1895 (Rasmus Meyer Collection, Bergen). The initial title was After the Fall indicating biblical overtones in the motif: the man as the penitent sinner and the woman as the victor after the sexual act.

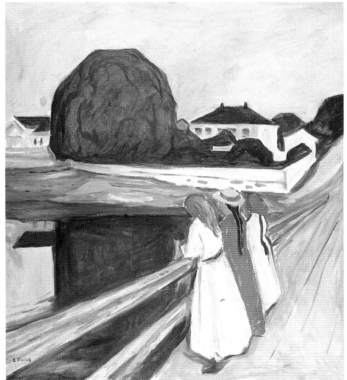

The Sick Child, 1925
Det syke barn
Oil on canvas
117 x 116 cm (46 in x 45 ⅝ in)
M 51

Munch produced no less than six versions of The Sick Child over a period of 40 years. All versions hark back to the memory of his sister Sophie who died of tuberculosis aged 15. Munch himself said: 'these [the paintings] are all different from each other and each contribute to expressing what I felt on the first occasion.'

The Girls on the Bridge, c. 1927
Pikene på broen
Oil on canvas
100 x 90 cm (39 ¼ in x 35 ⅜ in)
M 490

This is yet another replica of one of the main motifs in Munch's art. The Girls on the Bridge has been seen as one of Munch's most harmonious and lyrical paintings, but with clear erotic undertones. The three young girls stare down into the water where the large tree - which can be interpreted as a phallic symbol - is reflected in the summer night.

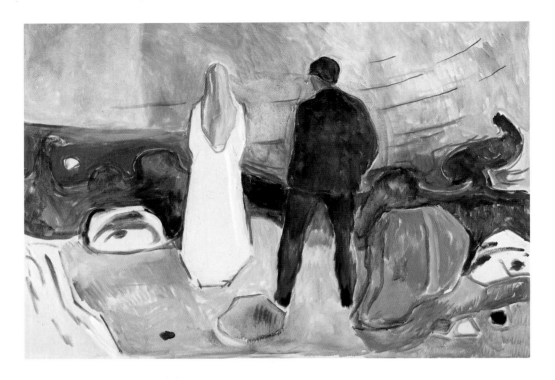

The Lonely Ones, c. 1935
De ensomme
Oil on canvas
90.5 x 130 cm (356 ¼ in x 51 ⅛ in)
M 29

*On the initiative of Edvard Munch, an
exhibition of young German art was
arranged in Oslo in 1932. It included
colourful, almost vulgarly intrusive
painting which clearly fascinated and
affected him, as can be seen for example in
The Lonely Ones and The Ladies on the
Bridge, where the colours crackle and the
strength of light is unusually exaggerated.*

**The Ladies on the Bridge,
c. 1935**
Damene på broen
Oil on canvas
119.5 x 129.5 cm (47 in x 50 ⅞ in)
M 30

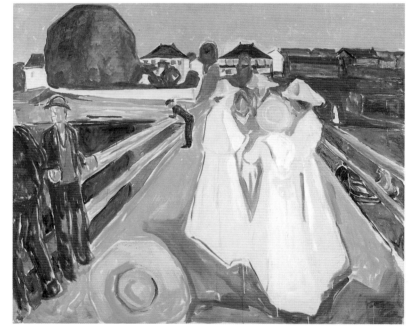

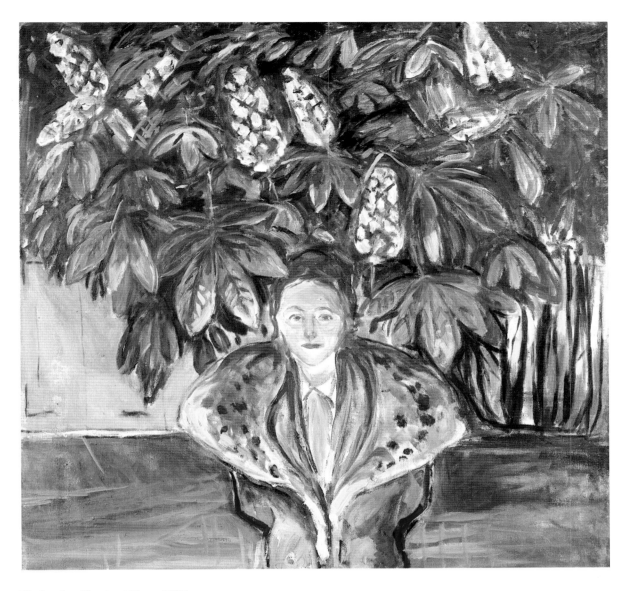

Under the Chestnut Tree, 1937
Under kastanjetreet
Oil on canvas
116.5 x 119cm (45 ⅞in x 46 ⅞in)
M31

One of the high points of the 1930s is the portrait of Munch's foremost model of that decade,
Hanna Brieschke. The picture in its simplified form is a pure portrait of a model with no literary
connotations whatsoever but clearly shows that Munch still had 'the painter's claw' when inspired
by a motif.

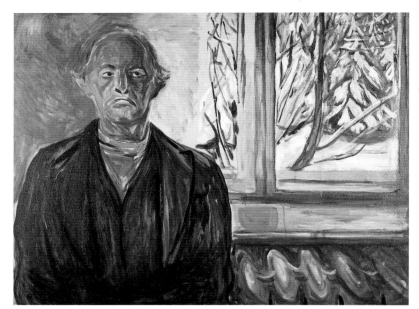

Self-portrait by the Window, c. 1940
Selvportrett ved vinduet
Oil on canvas
84 x 107.5 cm (33 in x 42 ¼ in)
M 446

The self-portraits from the last decade of Munch's life all have the real motif of the old man encountering death. Munch is merciless in his psychological examination. An icy loneliness but also human defiance emanates from the stubborn face towards the coldness of death which awaits him and which has already covered nature outside in a shroud.

Self-portrait. Between the Clock and the Bed, 1940–42
Selvportrett. Mellom klokken og sengen
Oil on canvas
149.5 x 120.5 cm (58 ¾ in x 47 ⅜ in)
M 23

With the stance of an old man, Munch places himself between two symbols of death, the clock and the bed. He stands there alone on the threshold between the sun-filled room behind him overflowing with works of art – what has been his life – and the bedroom where the shadow on the floor in front of him forms the shape of a cross.

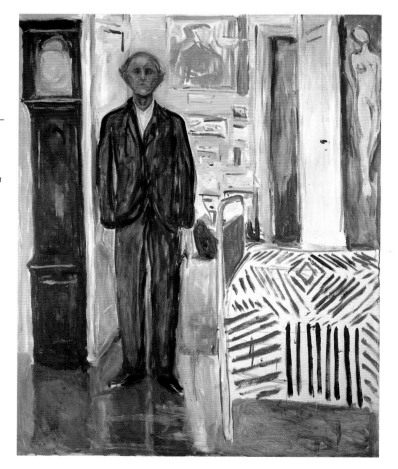

replicas of the motifs from his youth. *Ladies on the Bridge* from 1935 clearly shows how Munch, while retaining his uniqueness, clearly reflects impressions from contemporary art.

Munch also includes his approaching death in new designs of older motifs. *The Death of Marat* no longer reflects his personal crisis from the turn of the century. *In Marat and Charlotte Corday* (approx. 1930) we see one of Munch's young models with a knife hidden in a bouquet of flowers, a knife which will soon attack the painter himself.

The self-portraits which Munch created in the last decade of his life all have the underlying motif of an old man encountering death, where he is merciless in his self-analysis.

With the greatest consistency throughout his life Munch created a life's work which would not only enable the deepest problems of the century to live on into our time, but which also says something about human existence which can hardly be put into words. Right up to the last days of his life, in line with Kierkegaard, Munch shed light on anxiety as an existential problem.

EDVARD MUNCH'S GRAPHIC WORKS

by Gerd Woll

EDVARD MUNCH'S GRAPHIC WORK holds a unique position, in terms of both quality and quantity. It spans a period of 50 years (1894 – 1944) and covers a total of approximately 850 catalogue numbers divided between the three traditional graphic techniques of etching, lithography and woodcut as well as hundreds of what are known as hectographs. On his death, Munch bequeathed all his works of art to the City of Oslo and, besides paintings and drawings, the Munch Museum currently holds a collection of over 17,000 prints all created by this one artist. Furthermore, there are also a large number of graphic works spread though museums and private collections worldwide.

As a graphic artist, Munch was innovative in several fields and experimented with and simplified the various techniques in a way which places him in a class of his own even in an international context. Munch developed his capabilities with roughly the same amount of enthusiasm and skill in all the most important graphic techniques. In the main he worked with professional printers and did not produce large editions alone. However, at his death he also left a number of more experimental prints which clearly show that he was also in command of the technical aspect of the process.

A typical feature of Munch's graphic work is that he normally did not number his prints or state the size of the edition. Nor did he have the plates destroyed once printing was complete but, on the contrary, took great pains, at great expense, to preserve his stones and plates so that he could take further impressions at a later date. Consequently, in many cases many years may have passed between the date when Munch worked the plate and the time the last print was pulled from it. It is evident that this led to great variation in the quality of prints from the same plate but the reprints were done in Munch's own lifetime and largely under his control. We are aware of only very few examples of posthumous reprints of Munch's graphic work.

In addition to his works of art, Munch also bequeathed all his

Detail
Two Women on the Shore, 1898
To kvinner på stranden
Woodcut with gouges and fretsaw
454 x 516 mm (17 ¾ in x 20 ¼ in)
MM G 589-9 Sch. 117

The theme of the old and the young woman was first developed for the playbill for a performance of Peer Gynt in 1896 and is developed further in this beautiful woodcut. It is carved into a block which is divided into sections using a fretsaw, and in many later prints the block has also been rolled with several colours in addition to the divided sections. In some prints he also uses linoleum and even paper stencils for further colour accents in the foreground.

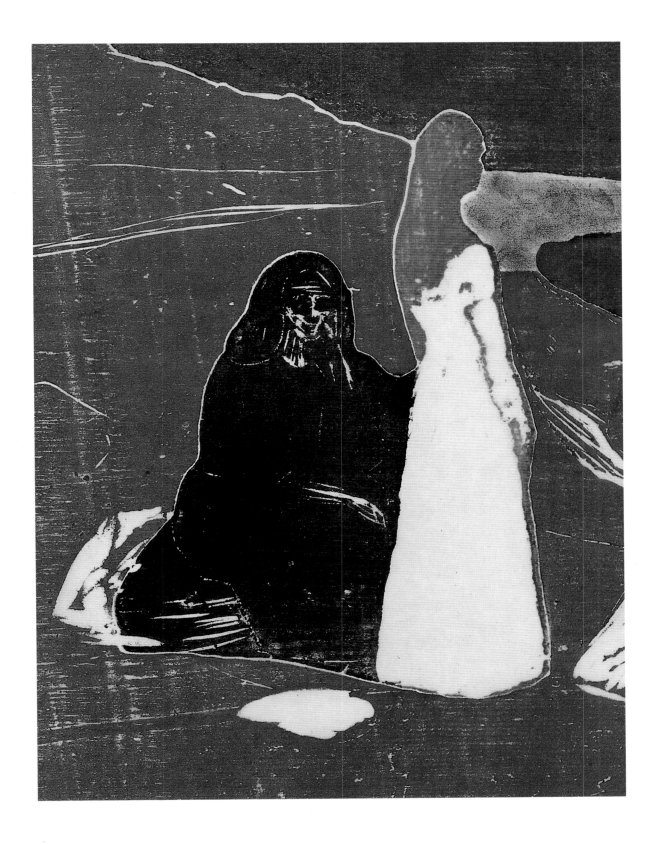

printing plates to the City of Oslo, and the Munch Museum therefore holds a large collection of lithographic stones, woodblocks and metal plates as well as three presses and some tools and printing equipment. While this is very important and interesting material for the researcher, it was also a way for the artist to ensure that no prints were pulled from his stones and plates after his death.

Intaglio, relief and surface printing

Traditionally, printing methods are divided into the main groups of intaglio, relief and surface printing, according to the techniques on which printing is based. Intaglio prints normally use a metal plate, which is prepared so that the ink lies in the furrows and grooves in the plate. The principle is that the ink is not held on the polished surface but only adheres where there are lines, depressions or other types of incision. During the inking process all excess ink is removed. When a soft, damp sheet of paper is run through a press together with the plate, the paper is forced down into the grooves and absorbs the ink. The metal plates can be prepared in various ways and with various tools, by scratching, pricking or scraping marks directly into the smooth metal or by covering the plate with what is known as an etching ground, e.g. a layer of wax, and incising the design into this wax layer. The plate is then placed in an acid bath and the acid bites into the metal wherever it is not protected by the ground. Etching allows a number of methods of preparing the surface of the plate by using an aquatint ground or through direct treatment with acid in what is known as open-bite.

Munch used the term 'radering' for all forms of intaglio prints and did not specify the technique or type of tool used to prepare the plates. The term 'radering' has been retained in the Munch Museum's catalogues, although this is often supplemented by a more detailed description of the technique used.

Relief prints, as its name suggests, is based on the opposite principle, where it is the raised parts of the plate which take the ink and produce the impression. This method is almost solely associated with woodcuts, or the closely related lino-cuts, where the surplus, light areas are cut away. During the nineteenth century, woodcuts were normally carved in the end-grain of the woodblock, enabling large editions to be printed without wearing down the block excessively. The technique was frequently used for illustrations in books and papers, carved by skilled craftsmen copying photographs or works of

art. Munch was one of the first modern artists to carve along the grain instead of across the grain, something which also made it possible to produce large format woodcuts. He used almost all types of wood and his surviving blocks include rough planks in spruce or pine, primed blocks in oak, mahogany and other hardwoods, hardboard and wood veneers. His tools included gouges of various thicknesses, pointed and rounded as well as broader chisels for removing large areas. He also often used a fretsaw to cut blocks into sections for colour printing.

Surface printing is normally associated with lithography, printing from stone. Lithography was invented by Alois Senefelder at the end of the eighteenth century and quickly gained in importance as a commercial printing method. It was used by several artists in the first half of the nineteenth century but really took off towards the end of the century. Here the printing block is a thick, porous limestone, which is ground to provide a smooth and even surface on which the artist can draw directly using lithographic crayon or tusche. Then the stone is prepared by a fairly complicated chemical process which fixes the drawing to the surface of the stone.

Before inking, the stone is wetted thoroughly so that water is absorbed into the porous stone, with the exception of the part of the surface where the drawing makes it water-resistant. Then the stone is rolled with a greasy ink, which does not adhere to the places where the stone has absorbed the water. One problem with lithographic stones is that they are expensive, besides being heavy and unwieldy. They are also fragile and can easily be chipped or smashed. Consequently, there was great interest in discovering new materials to replace the expensive stone and good results were obtained using specially prepared zinc plates. In commercial printing these soon became more common than the traditional stones. Prints from zinc plates are often called zincographs. Munch also used lithographic zinc plates on a few occasions.

Another method which allowed artists to avoid working with the unwieldy stones altogether was to draw on paper and have the printer transfer the drawing onto a lithographic stone. Such transfer techniques were developed at an early stage and a number of special types of paper were produced to ensure the best possible result. A skilled printer, however, could obtain perfect transfers from normal paper and Munch preferred to place a relatively thin sheet of paper on a textured base before drawing on particularly grainy transfer paper. Many of his drawings for such transfer lithographs have also been preserved.

Munch's first graphic works

Munch made his first intaglio prints and lithographs late in the autumn of 1894 and continued to test the various techniques available fully during the winter of that year and the spring of 1895. It is probable that his decision to start working with graphics was fuelled by a desire to spread his art and a need to increase his income, and many of his first graphic works reproduce motifs used in his earlier paintings. During that first year he created graphic versions of many of his most famous motifs, such as the intaglio prints: *The Day After, Moonlight in St. Cloud, The Lonely Ones, The Voice* and *The Woman*, and the lithographs: *Puberty, The Scream, Madonna* and *Vampire*. The following year saw *Jealousy, Anxiety, Death in the Sickroom, By the Death Bed* and *The Sick Child*, and his first woodcuts, among which *Moonlight, Melancholy* and *The Voice* stand out.

The earliest intaglio prints were carried out using drypoint on copper, where lines are incised directly into the copper plate with a drypoint needle. The metal is forced up beside the line in what is known as a burr, a characteristic feature of drypoint prints. The ink is not only held in the line but also in the burr, so that the prints gain a slightly fuzzy line, which merges into a dense and soft black surface. This typical burr wears down very quickly during printing and the quality of the prints is noticeably reduced after very few runs through the press. Towards the end of the nineteenth century, however, it was discovered that the copper plate could be steel-faced by placing it in an electrolytic bath so that the entire plate became covered by a

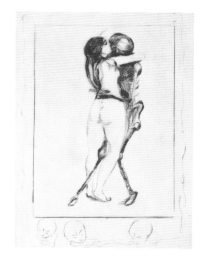

Death and the Woman, 1894
Døden og kvinnen
Drypoint on copper
294 x 210 mm (11 ½ in x 8 ¼ in)
MM G 3-21. Sch. 3

The drypoint repeats a motif which Munch had previously executed as a painting. The motif is a main theme in much of Munch's art: the difficult relationship to death and to women. In some versions of the drypoint the border with sperm and embryos is not inked.

The Day After, 1894
Dagen derpå
Drypoint and open bite on copper
191 x 278 mm (7 ½ in x 10 ⅞ in)
MM G 14-35. Sch. 15

This print was included in the portfolio of eight intaglio prints published by Meier-Graefe in June 1895, and is a direct reproduction of the Oslo National Gallery painting of 1894. The print exists in a number of states, which show how Munch built up the motif layer by layer with drypoint. The open bite gives large parts of the surface a greyish tone.

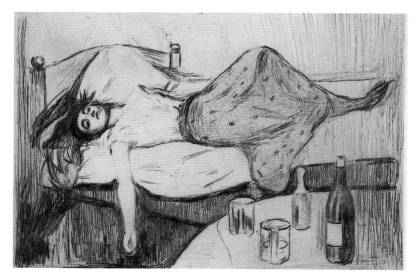

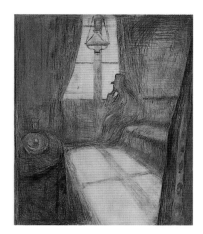

Moonlight/Night in St. Cloud, 1895
Måneskinn/Natt i St. Cloud
Drypoint, open bite and burnisher on copper
310 x 255 mm (12 ⅛ in x 10 in)
MM G 12-37. Sch. 13

The print is a mirror image impression of one of Munch's most popular motifs, executed in several painted versions between 1890 and 1895. The model for the seated man was the Danish poet Emanuel Goldstein, who was Munch's close friend in St. Cloud in 1890. In terms of technique the print shows advanced surface treatment using open bite and burnishing on copper plate.

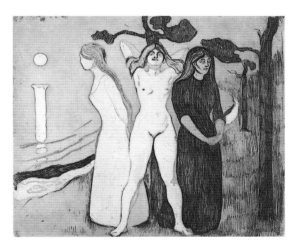

The Woman, 1895
Kvinnen
Drypoint, line-etching and open bite on copper
287 x 338 mm (11 ¼ in x 13 ¼ in)
MM G 20-27. Sch. 21

The print shows extended use of etching techniques with incising and open bite in several stages. The motif is the same that Munch painted in large format in the summer of 1895. There is also another version of the print, where the woman in black holds in her hands the severed head of a man.

Vampire, 1895/1902
Vampyr
Combination print: lithograph and woodcut
385 x 560 mm (15 ⅛ in x 22 in)
MMG 567-13 Sch. 34

The lithograph is a mirror image version of the earlier painting, drawn directly onto stone in Berlin in 1895. It is likely that the colour plates were first prepared in 1902. In the multi-colour prints the key stone is printed in black, another lithographic stone in red for the hair and a divided woodblock printed in blue, yellow and green.

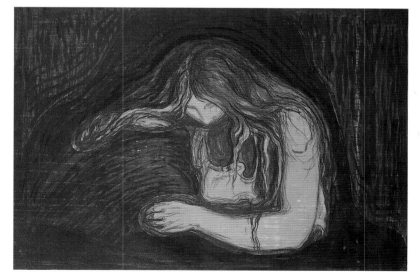

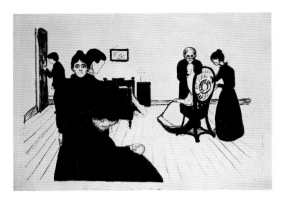

Death in the Sick Room, 1896
Døden i sykeværelset
Lithographic crayon, tusche and scraping tool on stone
387 x 552 mm (15 ⅛ in x 21 ⅜ in)
MM G 215-2 Sch. 73

The lithograph is a mirror image version of an earlier painting. In the lithograph, the autobiographical experience which forms the basis of the motif is further condensed to a purely emblematic image of the presence of death.

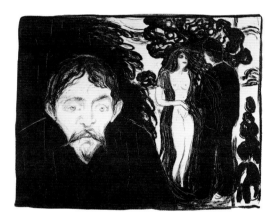

Jealousy II, 1896
Sjalusi II
Lithographic crayon, tusche and scraping tool on stone
473 x 574 mm (18 ½ in x 22 ½ in)
MM G 202-32. Sch. 58

The lithograph is a mirror image version of a painting with the same motif. The fact that it is a mirror image shows that it was drawn directly on to the lithographic stone. The contrast between the deep black surfaces and the finely drawn details is also characteristic of many of the lithographs Munch produced in Paris between 1896 and 1897.

Moonlight I, 1896
Måneskinn I
Woodcut with gouges and fretsaw
410 x 470 mm (16 ⅛ in x 18 ½ in)
MM G 570-36 Sch. 81

During his stay in Paris in 1896, Munch also began to create woodcuts. Here the motif is cut on either side of the woodblock and he also uses a colour block which is divided into three sections using a fretsaw.

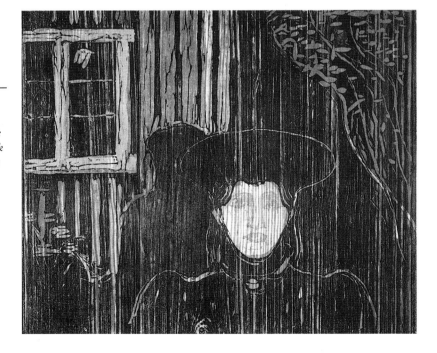

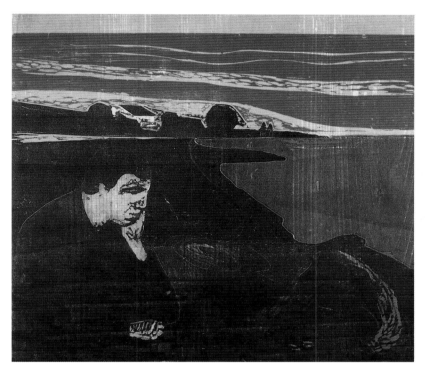

Melancholy I, 1896
Melankoli I
Woodcut with gouges and fretsaw
411 x 455 mm (16 ⅛ in x 17 ⅞ in)
MM G 571-17 Sch. 82

*This woodcut also repeats an earlier
painting, as a mirror image. It is
printed from two woodblocks which are
divided into two and three sections
respectively using a fretsaw. In 1902
Munch carved a new version of the
woodcut – probably under the
impression that the original had been
mislaid – and in this block the motif is
the right way round.*

Summer Night/The Voice, 1896
Sommernatt/Stemmen
Woodcut with gouges and fretsaw
376 x 557 mm (14 ¾ in x 21 ⅞ in)
MM G 572-2 Sch. 83

*The colour woodcut exists only in very
few impressions and the woodblocks have
not been preserved. The motif reproduces
in concentrated form a theme Munch had
previously executed in painting, several
drawings and one etching. The picture of
the woman surrounded by high fir trees
against the silent lake in the background,
produces the highly charged atmosphere of
a summer night.*

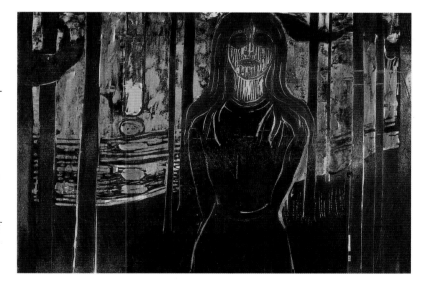

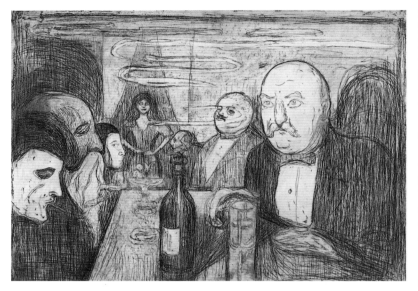

Kristiania Bohemians II, 1895
Kristiania–bohemen II
Line-etching, open bite and drypoint
on copper
281 x 382 mm (11 in x 15 in)
MM G 10-11. Sch. 11

*The bohemian environment is a central
motif in many of Munch's works from the
1890s. Around the coffee table sit six
slightly caricatured men, and centrally
placed in the background is a woman with
whom most of the men depicted had a
special relationship. From left to right can
be recognised Munch himself, Christian
Krohg, Jappe Nilssen, Hans Jæger,
Gunnar Heiberg and Jørgen Engelhardt.
The woman undoubtedly represents the
much-courted Oda Krohg. It was Hans
Jæger who invented the term Kristiania
Bohemia with his book of the same name.*

hard, steel film. This made it possible to print large editions and led to
an increase in the use of drypoint as a technique. Munch also made
use of this technique and all the copper plates for his early drypoints
have been steel-faced.

Soon afterwards, he also began to use different forms of etching
and often combined several techniques. He practically never used
traditional aquatint, instead obtaining similar effects using other
processes. Open-bite is used in very many of his etchings, often in
combination with stopping out. Corrections and additions were often
made in drypoint, but etching in acid could also be repeated several
times to attain greater variation in surface treatment.

The majority of his earliest intaglio prints can be found in a
number of states. After the first drawing of the motif he took one or
more proofs, continued to work on the plate and then took new
proofs until he was satisfied and printed an edition. He worked in the
same way with some of the lithographs and woodcuts. Changes
might often be added at a later stage and each such change to the
plate gives us a new state of the print. Placing a series of such state
prints side by side enables us to reconstruct practically the entire
production process. When we look at colour prints from several plates,
the picture becomes more complicated, as the technique allows the
plates to be combined in various ways, making it harder to talk about
states in the normal sense of the word.

As a graphic artist Munch must have been mainly self-taught and
what he needed in terms of technical skill he probably learned from

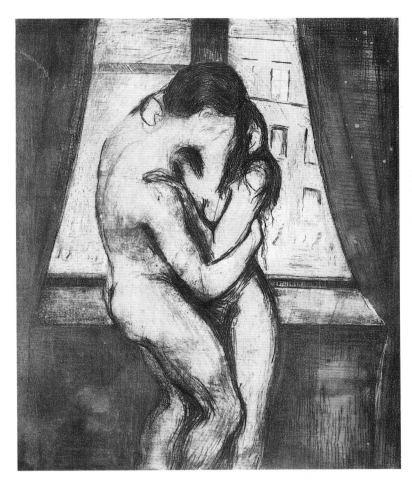

Kiss, 1895
Kyss
Line-etching, open bite, drypoint and
burnisher on copper
345 x 278 mm (13 ½ in x 10 ⅞ in)
MM G 21-5. Sch. 22

The paintings of the same motif all show a
clothed couple. The sculptural design of the
naked figures – particularly clear in the male
figure – may have been inspired by Munch's
friendship with the sculptor Gustav
Vigeland in Berlin in 1895. A painting
from 1897 completed while he was
executing the motif as a woodcut, is painted
on a woodplate with the etching as the
example.

Kiss IV, 1902
Kyss IV
Woodcut with gouges and fretsaw
470 x 470 mm (18 ½ in x 18 ½ in)
MM G 580-28 Sch. 102 D

In the woodcut, as in the paintings, the kissing pair are clothed,
unlike the etching with a corresponding motif. In this version,
abstraction has been taken to its extreme, and the man and the
woman stand up together as a dark silhouette against the
background formed only by the pattern in the wood.

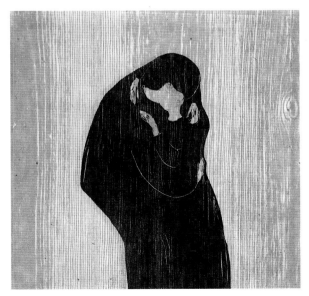

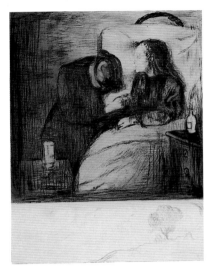

The Sick Child, 1894
Det syke barn
Drypoint, roulette and burnisher on copper
361 x 270 mm (14 ⅛ in x 10 ⅝ in)
MM G 7-18. Sch. 7

The print is a mirror image version of Munch's famous painting of 1885–86. In most versions of the drypoint a landscape has been added in a separate field under the main picture, reinforcing the dilemma of life and death. Munch himself saw this as one of his most important motifs and produced three graphic versions of it as well as painting a number of replicas.

the printers. Naturally, he would have been aware of the graphic work of leading French and German artists and several of them have justifiably been suggested as sources for the development of both motifs and style in Munch's art. These include, for example, artists such as Max Klinger, Félicien Rops, Odilon Redon, Alfred Besnard, Eugene Carrière, Paul Gauguin and Henri Toulouse-Lautrec, as well as old masters such as Rembrandt, Goya and Daumier. They were all part of the general cultural climate in which Munch lived and he naturally took advantage of what he could of this material.

Bearing in mind Munch's drawing skills and steady hand, it is hardly surprising that he was highly successful in using graphic techniques as a means of artistic expression. When he took up graphic work in 1894, he was far from a novice as an artist. One of Munch's most famous motifs of all, also among his graphic work, is *The Sick Child*. The drypoint from 1894 is a fairly accurate but mirror image version of the painting completed almost ten years earlier, carried out using drypoint and roulette in a full six states. In the first, the design still appears to be somewhat grey and tentative. In the only examples we know of this state he has drawn in a landscape in pencil under the picture itself. In later states this landscape has also been incised into the plate, only to be removed once more in the final state of the print. However, there are also a number of other changes which make it interesting to see how Munch worked through this motif, layer by layer, almost as intensely as he worked on the first version in oils. The figures are worked out with thicker and thicker lines and appear in increasingly greater contrast to the white bedclothes and the pale face of the sick

The Scream, 1895
Skrik
Lithographic crayon, tusche and scraping tool on stone
352 x 251 mm (13 ¾ in x 9 ⅞ in)
MM G 193-2. Sch. 32

The Scream is undoubtedly the most famous picture of the twentieth century. The lithograph, which repeats the motif from an earlier painting, was reproduced in the newspaper La Revue Blanche in December 1895 accompanied by a prose poem in French. Under the motif is the following text in German: 'Geschrei. Ich fühlte das grosse Geschrei durch die Natur'. Not all versions of the lithograph include this text.

Madonna, 1895/1902
Madonna

Lithographic crayon, tusche and
scraping tool on stone
605 x 440 mm (23 ¾ in x 17 ¼ in)
MM G 194–120. Sch. 33

*Printed in three colours. The key stone
was produced in 1895 while the colour
plates were not created until 1902. This
example is printed in black from the key
stone and red and blue from two other
stones. The motif reproduces a previous
painting, but with the addition of a
border of embryos and sperm. The border
was considered highly controversial and in
many editions it has been omitted in
printing.*

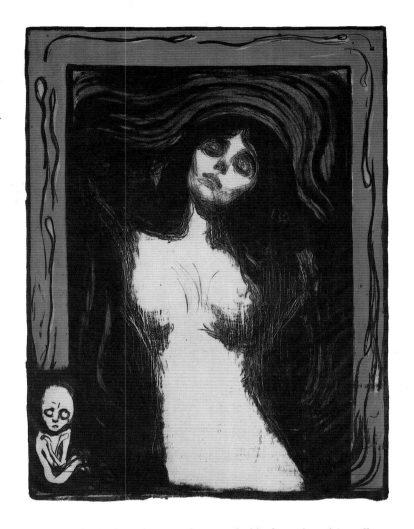

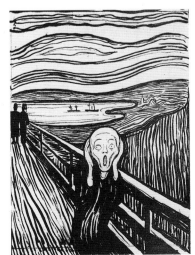

child herself, which is almost indistinguishable from the white pillow.

It is assumed that Munch also created his first lithograph, *Puberty*, in
Berlin in the late autumn of 1894, and we know that the portraits of
Harry Graf Kessler were created in April – May 1895. In an
unpublished diary, Graf Kessler describes an episode in Munch's room
when he was working on the lithograph. The hotel manageress came in
and confiscated the easel on which the stone was placed, presumably to
cover an unpaid bill, and Munch, apparently unmoved, then attempted
to continue work with the stone leaning against a chair. Graf Kessler
continues that in order to make things easier for Munch he wanted to
ask Joseph Sattler to teach him to create transfer lithographs, so that he
could draw on paper instead of on stone.

This gives an interesting insight into Munch's method of working
in these first lithographs. How and where he did learn of the

opportunities offered by transfer lithography, however, remains unclear. While he did not create pure transfer lithographs until the following year in Paris, some of the lithographs from 1895 also show signs that the rough outline of the drawing itself may have been transferred. In *The Scream*, for example, the motif is printed the same way round as in the painting, which in itself indicates that the image on stone was preceded by a drawing. If we look at the print in more detail, we can also see that under the strong tusche lines lies a thinner outline in crayon, in which the motif ends several centimetres above the final design. In all likelihood Munch first drew the motif on paper with lithographic crayon, transferred this to stone, and then continued with tusche directly on the stone. A similar procedure may have been used for *Madonna*, which is also not a mirror image of the painting. In this work, besides lithographic crayon and tusche, Munch also makes great use of a pointed scraping tool to scratch fine lines into the stone.

Colour printing

In the winter of 1896 Munch moved to Paris. One of the reasons may have been that he now seriously wished to focus on printmaking, and therefore was keen to benefit from the expertise of the great printers in Paris. Another reason behind the move is that many of Munch's friends from Berlin had left the city, many of them for Paris.

The problems which Munch focused on in depth in Paris included various methods of making colour prints and in this field Paris had considerably more to offer than Berlin. Thanks to the increase in the popularity of lithography around 1890, soon a number of painters tried their hand at this technique, and, despite the fact that colour lithography was long seen by many artists and collectors as being an inferior technique, such prints soon won great popularity in other circles. In 1893–1894, Roger Marx put together two graphic portfolios which became highly significant for the further development of graphic art. The selection was daring and it came to be seen as representative of modern printmaking. These portfolios were published by Ambroise Vollard, who published two further portfolios in 1896 and 1897.

Munch arrived in Paris in February 1896 and his natural place at the forefront of modern art was assured when he also contributed a print to Vollard's portfolio, namely the lithograph *Anxiety*, printed in red and black by the famous lithographer Auguste Clot. The normal

August Strindberg, 1896
Lithographic crayon, tusche and scraping tool on stone
600 x 463 mm (23 ½ in x 18 ⅛ in)
MM G 219-8 Sch. 77

In the first half of 1896, Munch and Strindberg spent time together in Paris. Strindberg's experiments with alchemy fed many delusions and his fear of rays sometimes produced violent fits. In the first version of Munch's lithographic portrait, the picture is encircled by a zigzag line and the naked figure of a woman and the name is misspelled. In some prints the border is omitted and somewhat later Munch corrected the name and drew over the female figure.

The Urn, 1896
Urnen
Lithographic crayon, tusche and
scraping tool on stone
460 x 265 mm (18 in x 10 ⅜ in)
MM G 205–27 Sch. 63

The motif was developed in parallel with
Munch's work on illustrating
Baudelaire's poem Les Fleurs du Mal.
The lithograph is trimmed and pasted on
grey card, a method of mounting which
Munch often used in his early lithographs
and woodcuts.

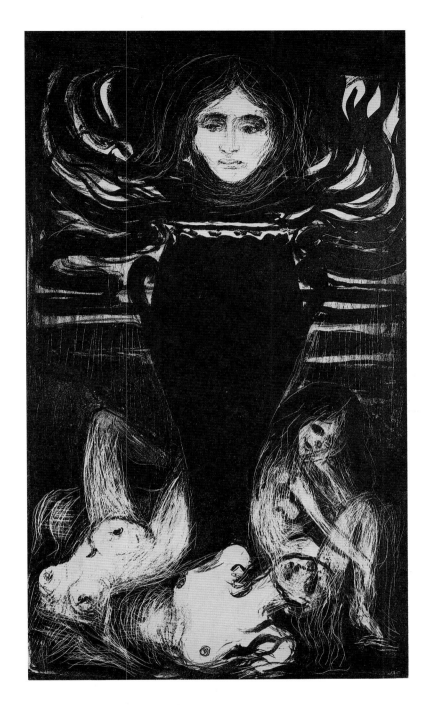

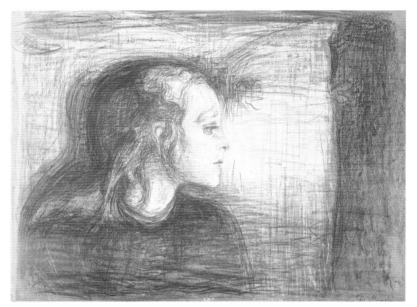

The Sick Child, 1896
Det syke barn
Lithographic crayon, tusche and
scraping tool on stone
414 x 588 mm (16 ¼ in x 23 ⅛ in)
MM G 203-10. Sch. 59

*Printed from five lithographic stones. The
key stone is produced using lithographic
crayon on paper while the coloured stones
are further worked on directly onto the
stone. The lithograph was created in
Paris, the same year that Munch
completed a replica of the painting of
1885–86 commissioned by the
Norwegian art collector Olaf Schou.*

principle for colour prints is to use a separate plate for each colour,
but in his print for the portfolio Munch simplified this process. *Anxiety*
was printed in two colours from one stone which was rolled with
black ink on the lower part and red in the upper part. Whether this
was the invention of Munch himself or the printer we do not know,
but the process displays an audacity and daring which is entirely
typical of Munch.

Munch's masterwork in the colour lithograph *The Sick Child*, was
also printed by Clot in 1896. Munch's good friend from that time, the
German painter and printmaker Paul Herrmann, gave an often-
quoted description of how that lithograph was printed: 'The
lithographic stones with the large head were already lying side by
side in rows ready to be printed. Munch arrived, stood in front of the
row, closed his eyes, and waved his fingers in the air without looking,
ordering, 'Print grey, green, blue, brown.' Then he opened his eyes
and said to me, 'Let's go and have a schnapps.' And the printer printed
until Munch returned and once more without looking ordered
'Yellow, pink, red' and so it went on a couple more times.'

Although the story was told many, many years later and possibly
bears the signs of having improved in the telling, in the main it
appears credible. Herrmann was not one of the most sensational
artists of the period, but some technical finesses in his graphic art
show an astounding similarity with Munch, and it is by no means
certain that Munch himself was the pioneer in the field. We know, for

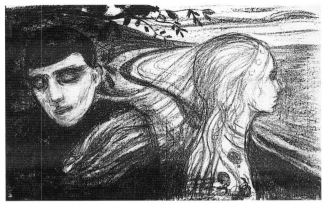

Separation II, 1896
Løsrivelse II
Lithographic crayon on paper, transferred to stone
416 x 645 mm (16 ⅜ in x 25 ⅜ in)
MM G 210-19 Sch. 68

This is a pure transfer lithograph, created in Paris and printed by Auguste Clot. It appears that the drawing was carried out using an artist's portfolio as a base, where its canvas texture is transferred to the lithograph. The woman is moving away from the man, but her hair still ties her to him like a visible band and is the direct cause of the man's pain expressed by his bleeding heart.

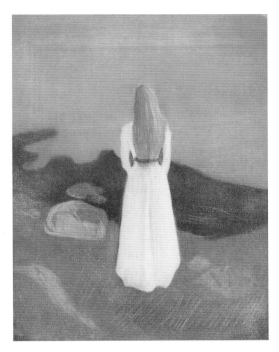

Young Woman on the Shore, 1896
Ung kvinne på stranden
Burnished aquatint on zinc
288 x 219 mm (11 ¼ in x 8 ½ in)
MM G 801-1 Sch. 85

The motif is burnished and scraped out with a burnisher, and the plate is then inked with the finest nuances in blue, yellow and red using dollies. A total of 11 colour prints of this print are known, and all differ in some respect. The female figure in white appears in several of Munch's works, and represents innocence, purity and beauty.

example, that Herrmann combined lithography and woodcuts in colour printing as early as 1896, while we are not aware of such combination prints on Munch's part until several years later.

Munch produced a couple of pure transfer lithographs with Clot in 1896, *Attraction II* and *Separation II*, which are both drawn using lithographic crayon on paper. To obtain texture in the drawing, he used an artist's portfolio as a base, where the rough canvas-like surface has been transferred to the drawing. Both the lithographs are also printed in a few multi-colour examples, but these are fairly discreet and subdued in their use of colour.

The use of metal plates also offered several opportunities for colour printing and during his time in Paris, between 1896 and 1897, Munch completed a number of very fine prints in burnished aquatint, a technique similar to mezzotint.

On a ready-prepared mezzotint plate ink is held densely and evenly over the entire plate producing a completely black print. The motif is then scraped or burnished out. Unlike drypoint, line etchings and most forms of normal drawing, the artist works from dark to

light, and forms the motif out of the light parts instead of using lines and contours. The technique is ideally suited to fine, nuanced transitions and soft surface effects, and throughout the nineteenth century was very popular in reproductive work. The technique became incredibly popular in the USA and Britain in particular, and was also used by some artists.

Munch – like Paul Herrmann – used a somewhat simpler method than the original mezzotint technique. Instead of preparing the copper plates with a rocker, he bought zinc plates which were already prepared with an aquatint ground. The motif was burnished out in the same way as in a mezzotint and the plate was then printed either in black or as a colour print. For inking the colours he used dollies, which were dipped in ink and then dabbed in the desired location on the plate (*à poupée*). Because the plates had to be re-inked for each print, it was hardly possible to obtain two identical impressions. Nor are zinc plates able to withstand very many printings before they wear down, and the maximum number of colour prints is around ten to twelve, as a rule fewer.

It was in Paris that Munch also began to carve woodcuts, and his work in this field came to have great significance for the further development of this type of graphic art.

The artists most often cited as possible precursors of Munch's in this field are Paul Gauguin and Felix Vallotton, but although it is easy enough to find similarities between their art and that of Munch, it is difficult to demonstrate any direct influence in the use of woodcut as a printing method. Munch's earliest woodcuts can rather be seen as logical extensions of his work on lithographs created at the same time. The strong, black lines in lithographs such as *The Scream* and *Anxiety*, have led to many misunderstandings as to the technique, and it is common for them to be taken for woodcuts. The large, dark areas in lithographs such as *Death in the Sickroom*, *Jealousy*, etc. have the silky, velvet-black appearance of lithographs but clearly show that Munch developed his graphic images by using simple surfaces and lines in a way which was closer to woodcut.

Although he had also obtained many unique effects with his black and white graphics, it is likely that the *painter* in Munch missed the opportunity of using colour as an element in his art. Possibly the process of colour lithography and burnished aquatint, in the long run, was too time-consuming and complicated for his nature. Woodcut, on the other hand, presented new and almost undreamt-of possibilities. The plates could be inked with different colours in the same way as

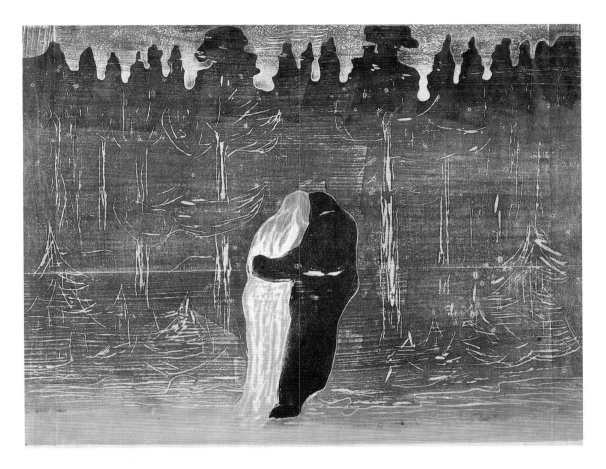

Towards the Forest II, 1915
Mot skogen II
Woodcut with gouges and fretsaw
504 x 647 mm (19 ⅞ in x 25 ⅜ in)
G 644-7 Sch. 444

The two woodcuts for this print were first carved in 1897 and printed in many editions. In the early prints, however, the figure of the woman is naked. In 1915 Munch worked on these plates further and changed the key plate and the colour plate. The new prints are often printed in radiant colours and the woman appears to be dressed.

with burnished aquatint, and they could be divided into separate sections, which could be inked individually. He used a fretsaw for this, and cut out the individual parts with great skill. As far as we know, Munch was the first artist to use such a method. Each separate part was inked with the desired colour and the entire block was reassembled like a jigsaw puzzle and printed in a single operation instead of printing many plates one on top of the other. Dividing up the motif in this way also strengthened the composition, which Munch often exploited as an extra feature.

For such colour printing Munch tended to use a key block where he carved the actual motif itself and a divided plate for printing the other colours. However, Munch could make colour woodcuts even more complicated by inking the plate with several colours at the same time, also in combination with divided woodblocks. A good example of this is *Towards the Forest* where the entire key block is usually inked with three colours, and the colour block is divided into many sections, which are printed in different colours.

Experimental lithographs and woodcuts 1898–1899

When he left Paris early in the summer of 1897, Munch travelled home to Norway where he spent most of the subsequent years. He probably brought with him a small printing press which he could use himself to print lithographs and woodcuts, and in the next few years he created a number of lithographs and woodcuts of an extremely experimental nature. The unfinished and almost tactile handiwork of these prints gives them a quality all of their own, which the artist himself cannot have been blind to. Besides this he also printed some lithographs at Petersen & Waitz in Kristiania (Oslo).

During 1898 he completed four very special lithographs: *Woman with Urn*, *Burlesque Couple*, *Desperate Woman* and *Desire*, which all have in common the fact that they use stones prepared and printed by Munch himself. These lithographs exist in a number of states – in fact each impression is unique. Coincidence appears to have played a major role in the execution, calling to mind August Strindberg's ideas on coincidence as a creative factor. Several of Munch's woodcuts at this time also bear the unmistakable signs of having been printed by the

Two Women on the Shore, 1898
To kvinner på stranden
Woodcut with gouges and fretsaw
454 x 516 mm (17 ¾ in x 20 ¼ in)
MM G 589-9 Sch. 117

The theme of the old and the young woman was first developed for the playbill for a performance of Peer Gynt in 1896 and is developed further in this beautiful woodcut. It is carved into a block which is divided into sections using a fretsaw, and in many later prints the block has also been inked with several colours in addition to the divided sections. In some prints he also uses linoleum and even paper stencils for further colour accents in the foreground.

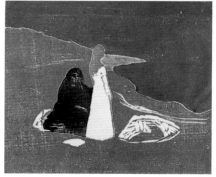

Blossom of Pain, 1898
Smertens blomst
Woodcut with gouges
460 x 327 mm (18 in x 12 ¾ in)
MM G 586-16 Sch. 114

This motif was first used as the frontispiece to an issue of the German periodical Quickborn, with texts by August Strindberg and illustrations by Munch. The man bears Munch's features, and is the closest one gets to an artistic credo in his work. Art is created from the lifeblood of the artist, like the beautiful flower which shoots up from the earth beside the suffering man.

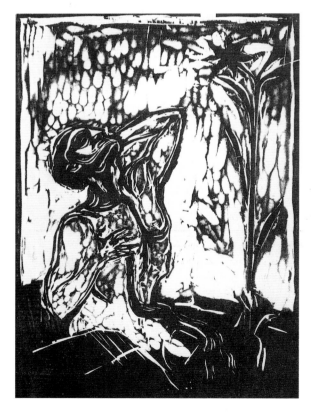

Desire, 1898
Begjær
Lithographic crayon, tusche and scraping tool on
stone
303 x 457 mm (11 ⅞ in x 17 ⅞ in)
MM G 234-31 Sch. 108

*Munch prepared the stone and printed this lithograph by
himself. The various impressions therefore vary
considerably. The motif is burlesque, and the male heads
are drooling over the naked figure of the woman who lies
stretched out as if a human sacrifice.*

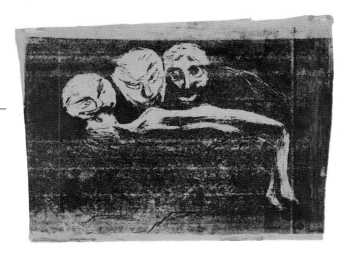

Two Human Beings/The Lonely Ones, 1899
To mennesker/De ensomme
Woodcut with gouges and fretsaw
395 x 557 mm (15 ½ in x 21 ⅞ in)
MM G 601-1 Sch. 133

*The woodcut repeats in mirror image a motif which was
previously executed as a painting and as a drypoint. It is
printed from a plate which is cut into three sections using a
fretsaw, and the sections are each inked with a different
colour. In some impressions he has used stencils for the
moon and the moonlight and in later prints he also used
paper stencils for strong blobs of colour in the shore area.*

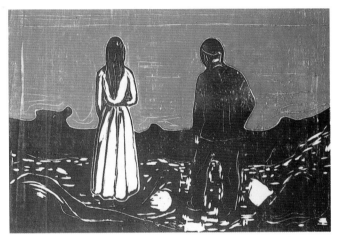

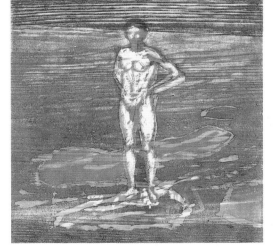

Man Bathing, 1899
Badende mann
Woodcut with gouges
442 x 444 mm (17 ⅜ in x 17 ⅜ in)
MM G 594-2 Sch. 126

*Munch depicts bathing men and women in many works. He was clearly
fascinated by the opportunity this gave for realistic life studies and images of
man at one with nature. The woodblock is carved on both sides using the
gouge and, in addition, many of the prints use a stencil with the standing
man. Both sides of the block are inked with several colours at the same time.*

artist himself, and on these we find the same fondness for rough brownish paper, torn or cut in an almost random manner which emphasises the character of packaging paper.

At this time Munch also developed another technique for taking imprints from woodblocks, what in modern art literature is referred to as *frottage* and is considered to have originated with the Surrealists. Instead of inking the woodblock and printing it in a press, he laid a sheet of paper over the block and rubbed it with a piece of coloured crayon. Unlike ordinary printing, such rubbings do not appear as a mirror image, that is to say they render the woodblock the same way round as it was carved. The first time Munch used such a technique was probably in 1897, when he created the poster for an exhibition in Kristiania. Then he first made a frottage from the woodblock of *Man's Head in Woman's Hair*, which was then transferred to a stone or plate and printed lithographically. Later he also created several pure frottages, sometimes reinforced by drawing or further work. In addition, we can see that in some later transfer lithographs he also used woodblocks as a base for the drawings, so that the grain of the wood produced an effect in the finished lithographs.

Breakthrough as a graphic artist 1902–1903

Towards the end of 1901 Munch decided to return to Berlin, with the clear aim of making a name for himself as an artist. This was largely successful, thanks to the excellent, new contacts he made. The art collector Max Linde was one of those who discovered Munch in 1902, and through Albert Kollmann in the autumn of 1902 he purchased an almost complete collection of Munch's intaglio prints and lithographs, and also ordered a graphic portfolio containing portraits of members of the family and their property in Lübeck. Gustav Schiefler saw Linde's collection of prints, and was so impressed that a short time later he decided to produce a complete catalogue of Munch's graphic work. Several exhibitions and increased sales also led to interest from art dealers keen to sell Munch's work, and in 1904 he signed a three-year contract with Cassirer on the sole right to all sales of graphic art in Germany. Although this contract caused Munch great resentment and brought in little income, it can be seen as a clear sign that he was now a graphic artist to be reckoned with. Schiefler's catalogue came out in 1907, and instantly became the standard work on Munch's graphic art – as it still is today.

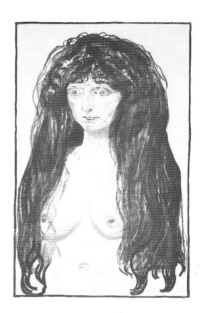

Woman with Red Hair and Green Eyes/The Sin, 1902 Kvinne med rødt hår og grønne øyne/Synden
Lithographic crayon, tusche and scraping tool on stone
695 x 400 mm (27 ¼ in x 15 ⅜ in)
MM G 241-13 Sch. 142

The multi-colour version of this motif is an expert colour lithograph where parts of the motif are transferred to the reverse of the stone which is then used as the colour stone. The green eyes are created by the printer dabbing a little blue on his fingertips and adding it to the yellow ink.

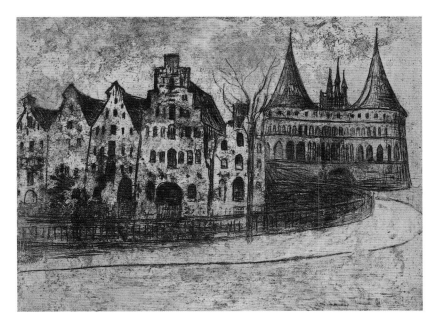

Lübeck, 1903
Etching on zinc
500 x 645 mm (19 ⅝ in x 25 ⅜ in)
MM G 90-2. Sch. 195

In 1902–03, Munch frequently stayed in Lübeck, where he created a portfolio of prints commissioned by Dr Max Linde. For this etching he used a large zinc plate which has a softer surface than copper plate. The etching is carried out with rough strokes and similarly rough treatment of the plate.

The Hearse/Potsdamer Platz, 1902
Likvognen/Potsdamer Platz
Line-etching, open bite and drypoint on copper
240 x 290 mm (9 ⅜ in x 11 ⅜ in)
MM G 66-28. Sch. 156

Even an everyday scene like this is given a darker undertone by the hearse passing across the square. The etching shows great use of open bite in combination with stopping out, so that certain areas are shown a gleaming white. The contour lines which appear where the various levels on the plate change are characteristic of open bite and very visible in this etching.

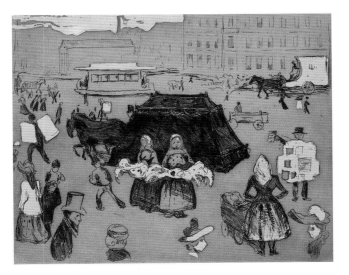

The increased interest from 1902 onwards also led to an increased need for prints. Munch was not particularly productive in terms of new prints from 1902 onwards, but he did reprint many of his previous motifs – generally in large editions. After this point the intaglio prints were almost solely printed by Felsing, who was expensive but had become considered the leading workshop for intaglio prints. Felsing's print shop had a passion for ink with a warm brown tone and often printed on paper which also had a distinct yellow tone. This contrasts with Munch's previous intaglio prints

which tended to be printed in clearer black and white or off-white paper. The lithographs and woodcuts were almost without exception printed by Lassally in Berlin, and in 1904 Munch had all his lithographic stones sent from Paris to Lassally. Greater popularity and an improved financial situation meant that he could order frequent editions of his most popular prints and print them on large sheets of high-quality paper.

Transfer lithographs and duplicate stones

Everything indicates that Munch must have been aware of transfer lithography techniques from the start, but it was not until after 1902 that his lithographs were mainly drawn on paper. However, there are some exceptions, not least the magnificent portrait of Eva Mudocci, also called *The Brooch*. This lithograph was originally drawn directly on the stone, but in 1915 it was printed on transfer paper sent from Germany to Norway, and transferred to a new stone. Some details have been changed on the duplicate stone, which was also printed in fairly large numbers.

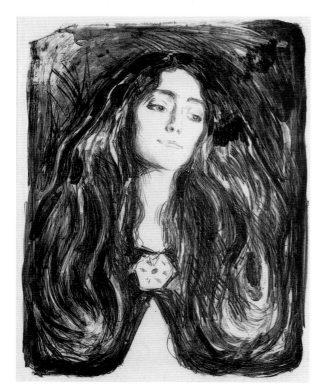

The Brooch/Eva Mudocci, 1903
Brosjen/Eva Mudocci
Lithographic crayon, tusche and scraping tool on stone
600 x 460 mm (23 ½ in x 18 in)
MM G 255-35 Sch. 212

Eva Mudocci was a famous British violinist, with whom Munch became acquainted in Paris in 1903. She gave numerous concerts around Europe, also in Norway. This magnificent portrait is drawn directly onto stone.

Streetworkers, 1920
Gatearbeidere
Lithographic crayon on paper,
transferred to stone
435 x 595 mm (17 ⅛ in x 23 ⅜ in)
MM G 418-29 Sch. 484

*Munch was fascinated by the renewal
taking place in the city around him, and
drew and painted a number of pictures
with workers as a motif. He later took up
the group of asphalt workers again as one
of the main panels in his proposal for the
decorations for Oslo City Hall.*

In 1909 Munch returned to Norway, and in the next few years he lived in various places on both sides of the Oslo Fjord until, in 1916, he settled down in Ekely on the outskirts of Oslo. In around 1910 he came into contact with a lithographer, Anton Peder Nielsen, who later took the name Kildeborg. Nielsen worked for various lithographic printers in Oslo until he established his own print shop in the 1920s, and became an invaluable assistant to Munch when it came to printing lithographs and woodcuts. In 1912 Munch installed a lithographic press in Hvitsten and in 1916 he set up a graphic workshop in the cellar. Nielsen often visited him there and printed on Munch's press.

While transfer lithographs still prevailed, it can also be seen that both in 1912 and in 1916 Munch was working directly on stone, and the same in around 1930.

By the outbreak of the First World War, most of Munch's stones were at Lassally's in Berlin, and this caused him a great deal of worry. This was partly because, naturally enough, he was uncertain about what might happen to them and also because it became impossible for him to order new reprints from Germany after the outbreak of war.

During the first months of the war he succeeded in having all his woodblocks and metal plates sent home from Germany and probably all the stones that he had transferred from Paris. In 1917 he received five stones from Lassally while the others were destroyed by having a cross scratched into them once Munch had ensured that he had prints for transferring to duplicate stones at home in Norway. Many of his

lithographs may therefore have been printed by Clot, Lassally and Nielsen – either from the original stone, or from the duplicate stone – over a period of 20 years.

Intaglio prints and woodcuts after 1910

Munch's interest in intaglio prints also grew in around 1913, at the same time as he obtained his own press to print them. When he got all his plates home from Germany in the autumn of 1914, he also worked further on many of them or pulled reprints from the old plates. There are often signs that he inked the plates himself and the prints have a far more experimental look than the more perfect professional editions. One of the more remarkable things that he did was to ink metal plates with normal oil paint which lay on top of a large part of the plates and not only in the grooves. Certain plates such as *Life* and *Landscape in Kragerø*, for example, might almost have been painted with a brush, and in every case the results are interesting, if not always equally successful. The majority of intaglio prints from these years are printed in very limited editions but in 1916, however, he had many printed in numbered and dated series

The Bite, 1914
Bittet
Etching on copper
197 x 276 mm (7 ¾ in x 10 ¾ in)
MM G 142-1. Sch. 396

Around 1913–14, Munch's interest in etching as a medium revived, and his work includes several prints with erotic motifs where joy appears to have replaced the previous problematic depiction of the relationship between man and woman. This etching was only printed by the artist himself in very few impressions.

The Pretenders: The Last Hour, 1917
Den siste time
Woodcut with gouges
433 x 580 mm (17 in x 22 ¾ in)
MM G 650-8 Sch. 491

During the First World War Munch carved a number of powerful woodcuts using motifs from Henrik Ibsen's drama The Pretenders. The civil war of medieval Norway combines with impressions of what Munch saw as a modern civil war in Europe. In The Last Hour he depicts the fateful period of waiting before the drama draws to its close when King Skule comes out to meet his slayers.

by Scheel in Oslo. However, after this point Munch's interest in intaglio prints appears to have been exhausted.

Woodcut was the graphic method which came to occupy Munch the longest. Even in the earliest woodcuts he used the actual texture of the wood itself, for example as in *Kiss III and IV*, where one of the plates is actually quite untouched by the gouge or other sharp tools. The entire decoration is made up of the fine lines, growth rings and knotholes in the wood, creating a background which gives the picture life and atmosphere. It is quite certain that Munch must have worked on the woodblocks to strengthen these lines. It is likely that he used sandpaper to remove some of the soft wood, so that the hard edges appear more clearly. In some of the woodcuts from 1917 which used motifs from Henrik Ibsen's play *The Pretenders* and particularly the one of *Skule* and *Bishop Nicholas in the Forest*, this special effect has been taken to the extreme. Here the lines of the wood give a feeling of nebulous unreality where the two heads appear like ghostly spirits. Munch goes furthest along these lines in one of his last woodcuts; according to documentation witnessed by his sister Inger, it was printed on his 80th birthday on 13 December 1943. The motif itself *Kiss in the Fields* is only carved in thin contour lines. The swirling,

The Girls on the Bridge, 1918
Pikene på broen
Combination print: woodcut and
lithograph
495 x 423 mm (19 ⅜ in x 16 ⅝ in)
MM G 647-20 Sch. 488

The image of the three girls on the bridge
is undoubtedly one of Munch's most
popular motifs and can be found in many
versions and variants. The woodcut is a
mirror image as it is carved directly into the
woodblock. The woodcut is printed in
black or blue and, in the multi-colour
versions, combined with a lithographic zinc
plate printed in red, yellow and green.

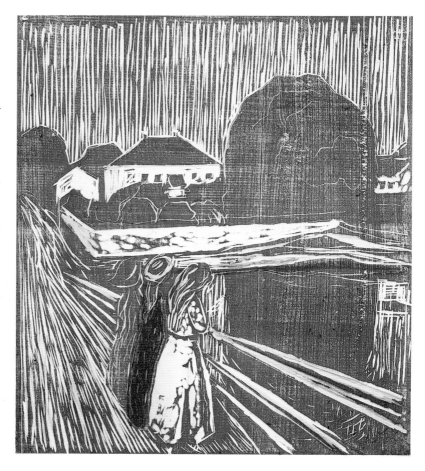

Sunbathing I, 1915
Solbad I
Woodcut with gouges and fretsaw
350 x 558 mm (13 ¾ in x 21 ⅞ in)
MM G 640-10 Sch. 440

In the summer of 1915 Munch drew and
painted a number of exuberant bathing
pictures, where the naked people are
sometimes almost at one with nature. The
red slabs of granite which he found both
at Hvitsten and on the island of Jeløy
create a sunny and warm background for
the models. For this woodcut, which
exists in a number of different coloured
versions, he used two woodblocks each
carved on both sides.

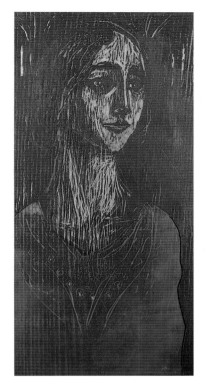

Birgitte III, 1930
Woodblock in aspen, worked with
gouges and fretsaw
593 x 324 mm (23 ¼ in x 12 ¾ in)
MM P 453

*Many of Munch's woodcuts are works of
art in themselves, and in this case it
appears as though many of the colours are
directly painted on the block with a brush.
Behind the narrow elegant figure of the
model, Gothic curved openings can be
seen which link to the woodcuts with
motifs from The Pretenders. The same
model was used in the new version of The
Trial by Fire carved in 1930.*

restless patterns of the cherrywood are what actually create the main
emphasis in this woodcut.

In 1915–1917 Munch also printed several more colourful, almost
gaudy, woodcuts, where he combined fretsaw technique and direct
painting to great effect. This concerned both new blocks, and reprints
from old blocks with or without reworking. In order to further
increase the opportunities for special colour effects, he also used
varying types of stencil cut in linoleum or card. He used these to
mask part of the plate or inked them in line with the various sections
of the block, laying them over the woodblock before it was printed.
Use of such stencils can be found in several examples of woodcuts
printed in this period, such as *Sunbathing*, the new version of *Towards
the Forest* and reprints of older blocks such as *Man Bathing, The Lonely
Ones* and *Two Women on the Shore*. The moon and the moonlight in the
two latter prints comes from stencils and in some impressions we can
clearly see that he has used the same stencils for both.

Munch's last graphic work, however, was not a woodcut, but a
new lithographic version of the portrait of Hans Jæger, originally
completed in 1896. The new version is very similar to the old one,
which was only printed in a very limited edition. Munch was
working quite intensively on this lithograph only a few weeks before
he died in 1944 and the printer brought the finished print out to him
after he had fallen ill in January 1944. Although the motif was
designed earlier and the new version is a mere repetition, it still has
an astonishing freshness and strength in the execution, which clearly
shows that the ageing master was in command of both his vision and
his craftsmanship until the very end.

That it should be precisely the portrait of Hans Jæger, bohemian
and anarchist, abused and driven out by the bourgeoisie and police in
Kristiania, which was his final work closes the circle in a thought-
provoking way. Hans Jæger was a determined naturalist, wrote his
books with an orthography which, incredibly radically, was based on
the Norwegian manner of speaking at a time when the written
language was still Danish, and he challenged modern artists to write
their lives – nothing else. He himself achieved this to the extent that
almost all of his books were banned due to their ruthless honesty –
particularly in their many erotic descriptions. Of the painters, it was
really only Munch who took Hans Jæger seriously, and honestly and
ruthlessly looked into his own experience and his own soul for motifs
and inspiration.

LIST OF WORKS

Numbers in italics refer to illustrations